MERTHYR TYDFIL
THROUGH TIME
Rhianwen Long

AMBERLEY PUBLISHING

First published 2014

Amberley Publishing
The Hill, Stroud, Gloucestershire, GL5 4EP
www.amberley-books.com

Copyright © Rhianwen Long, 2014

The right of Rhainwen Long to be identified as the
Author of this work has been asserted in accordance with
the Copyrights, Designs and Patents Act 1988.

ISBN 978 1 4456 1825 8 (print)
ISBN 978 1 4456 1833 3 (ebook)

British Library Cataloguing in Publication Data.
A catalogue record for this book is available from the
British Library.

Typesetting by Amberley Publishing.
Printed in Great Britain.

Introduction

Merthyr Tydfil is a beautiful and historically fascinating area of Wales. Rich landscapes, scenery and heritage mark out this town, which was once the iron capital of the world. The rich industrial heritage forged by ironmasters and mining has left indelible marks on the surroundings, in the form of housing, historic buildings and areas of outstanding beauty. Some buildings still stand and some areas remain as they have always looked, but in a town where there is much resilience and a pride in heritage, there are also many changes. Nothing shows the pace of change, the difference in perception and the beauty of the area like prints and photographs of that time, and the stark contrast between then and now will be clear in this collection of photographs from Merthyr Tydfil Central Library.

This book would not have been possible without the assistance of Jane Sellwood, Anne Yates, Jayne O'Brien, Mary Oates, Ruth James, Malcolm Evans, Saraan Oates, Sian Anthony and all other members of staff at Merthyr Tydfil Library Service.

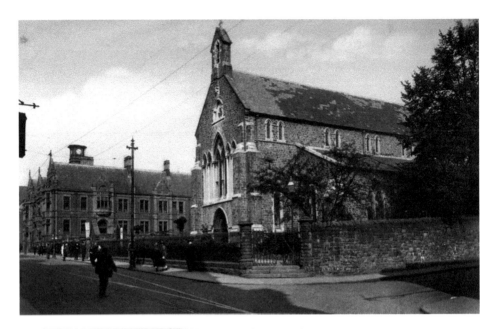

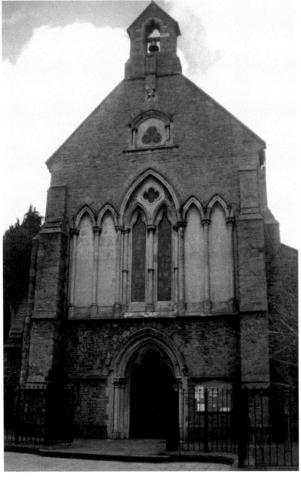

St David's Church

During the nineteenth
century, Merthyr's parish
church was St Tydfil's.
The church was mainly
Welsh-speaking and
so, to house the ever-
growing English-speaking
congregation, St David's
church was erected in 1847.
During the 1930s, the pulpit,
choir and chancel areas were
created, and although quite
modern at the time, they
were made in a traditional
manner so as to blend with
the rest of the church.
St David's became the
parish church in 1971 when
St Tydfil's closed. More
recent refurbishments
have seen the west end of
the church transformed
into a café-style area, with
armchairs and a children's
corner stacked with toys and
books. The church remains a
vital part of the community
and holds many activities and
events throughout the year.

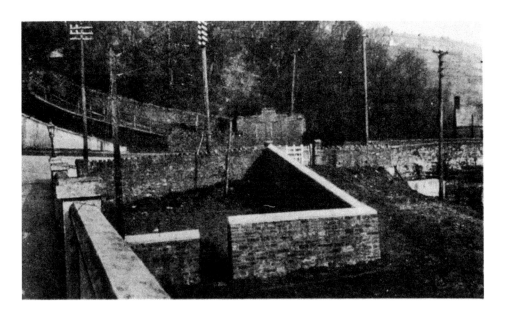

Quakers' Burial Ground and the Yard

This piece of land on the Pantannas Estate, owned by Mary Chapman, was officially opened by William Howe of Bristol in 1665. Until 1797, the 'Yard', as it was locally known, was used as a meeting place. When prominent Quaker Lydia Fell died, her will of 1700 stated that the Yard should be left to the Quakers. Until the 1890s, the land was used as a burial ground for the Quaker movement. As you can see, despite the passing of almost 300 years, the area is virtually unchanged. The Yard is now a Garden of Remembrance, a pleasant place to sit and contemplate.

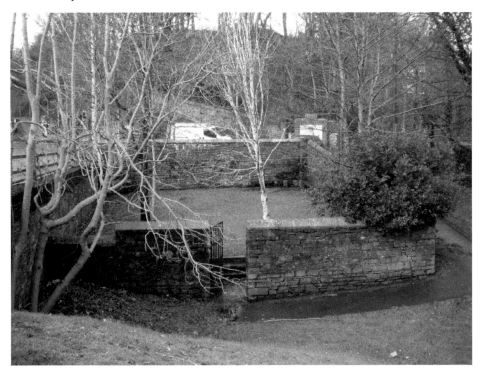

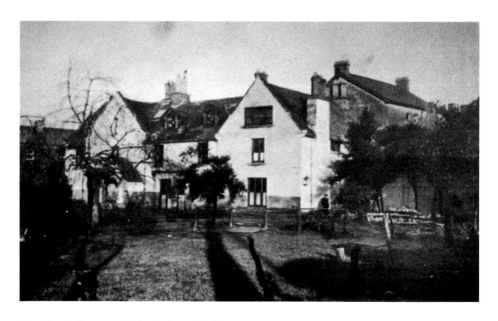

The Court House and the Labour Club

The current structure of the manor house was built in 1717 using local stone, and is thought to be built on the site of Ifor Bach's – Lord of Senghennydd – twelfth-century court. This is also where the name of the manor house is believed to have come from. Arthur Tristan (1884–1973), eminent pioneer of town planning and a notable writer of architecture, was born here. The Court House was originally surrounded by fields, and over the years it went through many structural changes, with new wings being added, along with new windows and doors, a Tudor Revival-style porch and refurbishments throughout. The building is the oldest one in the parish of Merthyr Tydfil, and was bought and turned into the Labour Club & Institute. After the Second World War, the club opened a Garden of Remembrance for the members that died during the war.

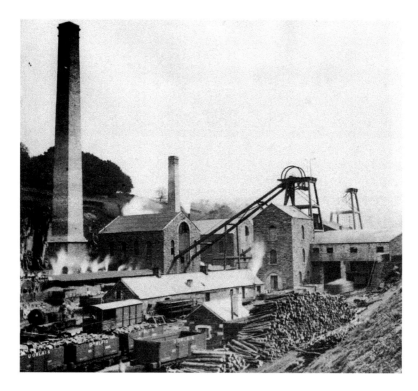

Nantwen Colliery

Sinking began at the Nantwen Colliery, Bedlinog, in 1878, but it took five years to reach the Brithdir Seam, at a depth of only 85 yards. Like the other collieries in Bedlinog, it was first owned by the Dowlais Iron & Steel Company, then the Guest Keen and finally Guest, Keen & Nettlefold Limited. In 1913, Mr Thomas Bevan was the manager and the company was a member of the Monmouthshire & South Wales Owners Association. Nantwen Colliery was sold in 1924. During the 1950s and 1960s, Mr F. M. Price was given a licence by the National Coal Board to open a small level that produced coal. However, it never again employed the number of miners that it did while owned by Guest, Keen & Nettlefolds, when it provided work for over 400 men. Closure of the colliery saw people leave the village for work elsewhere. The railway line, which was used to transport workers from Penywern and Dowlais, is now gone and the village relies on bus services now.

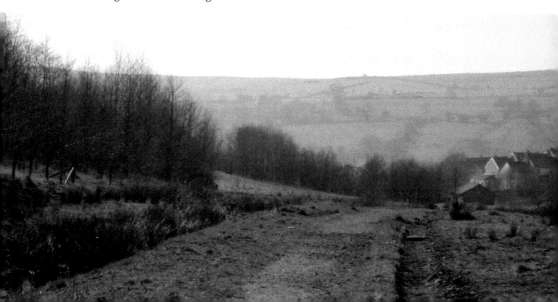

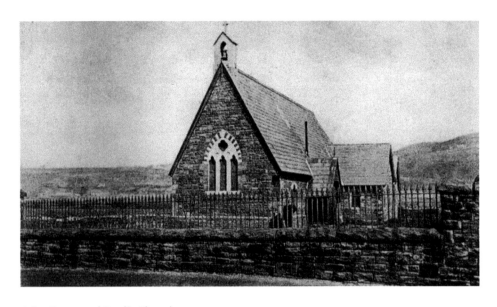

Saint Peter and Paul's Church

The church hall was the first church to be built in the village of Abercanaid. It was built in 1882 and, two years later, was licensed for Divine Service. The church was dedicated to St Peter and St Paul. However, the population soon grew too large for the small church hall and so, at the turn of the century, a new church was built adjacent to the old one. The deeds were transferred to the new church and, in 1912, the new church was consecrated by the then Bishop of Llandaf. The church building has been restored at least once in its history. However, by 2007, all services had to take place in the church hall as the building had deteriorated again. Planning permission has been granted for demolition of the church and the building of four detached premises.

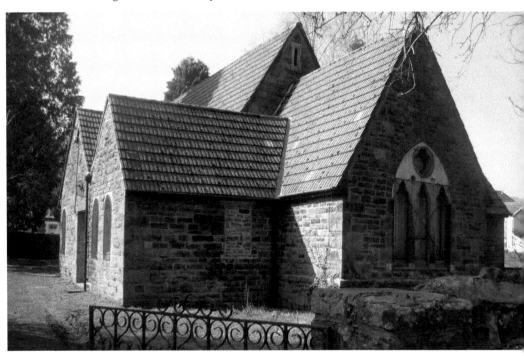

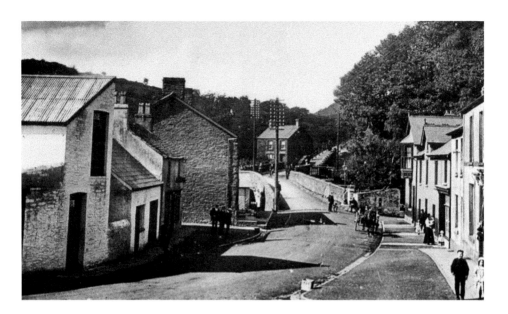

Quakers Yard

Until the second half of the nineteenth century, Quakers Yard was a rural village, with a corn mill, woollen factory and two inns. On the right of the picture above, at the start of the bridge, is one of the two inns, the Quakers Yard Inn, which was opened by the late eighteenth century. Caerphilly Road in Quakers Yard has obviously undergone some minor changes since the nineteenth century, but it is still recognisable from the old photographs. Horses and carts are no longer used as a form of transport, and no pedestrians can be seen, but there are plenty of cars on the road! Some buildings have now gone, replaced by a seating area and bus stop. Although modernised, the houses are still much the same, and the Quakers Yard Inn is still used as a public house.

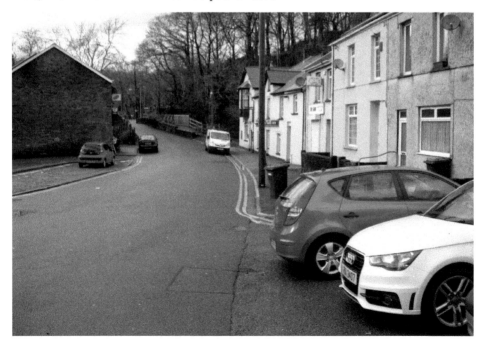

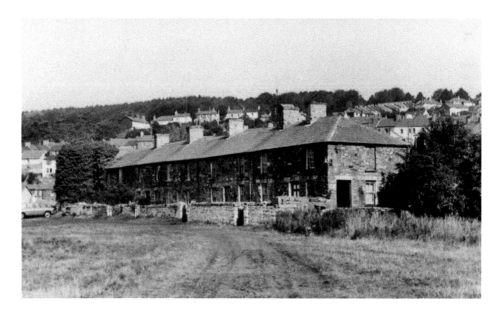

Chapel Row

Chapel Row was built in the 1820s for the workers of the Cyfarthfa Ironworks. In 1841, Joseph Parry, Wales' best-known composer, was born at No. 4. When he was nine years old, he was sent to work in the Cyfarthfa Mills. During the 1850s, the Parry family emigrated to the US and settled in Danville, Pennsylvania, where Joseph Parry became an ironworker. There was a strong Welsh community in the area and his musical talents shone as he became involved in strengthening the Welsh culture. The outward appearance of the cottages on Chapel Row hasn't changed much over the years, although the surrounding area has. No. 4 is now a small museum dedicated to Joseph Parry's life in Merthyr Tydfil. The cottage's interior has been set in the style of an 1840s house and shows the living conditions of the ironworkers.

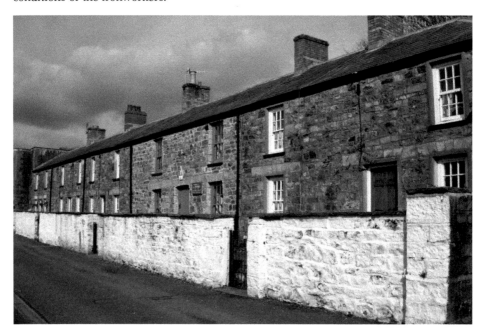

Pont-Y-Gwaith

Pont-y-gwaith translates as 'The Works Bridge' or 'Bridge to Work', and is a historical bridge over the River Taff at the lower end of the valley near Merthyr Vale. The original bridge at the site was made from wood, and underwent several repairs and rebuilding. It was there to allow traffic from the village and the nearby sixteenth-century ironworks to access the main road over the River Taff. During 1811, a committee was formed for the rebuilding of the bridge with stone. Today, the same stone humpback bridge that was built in 1811 still allows access over the River Taff. It is one of the oldest larger bridges still surviving in the Merthyr area. In 1989, access to the bridge was blocked for safety, and during 1992/93 the bridge underwent repairs provided by Mid Glamorgan County Council. It was awarded a commendation by the Civic Trust and is now a Taff Trail heritage site.

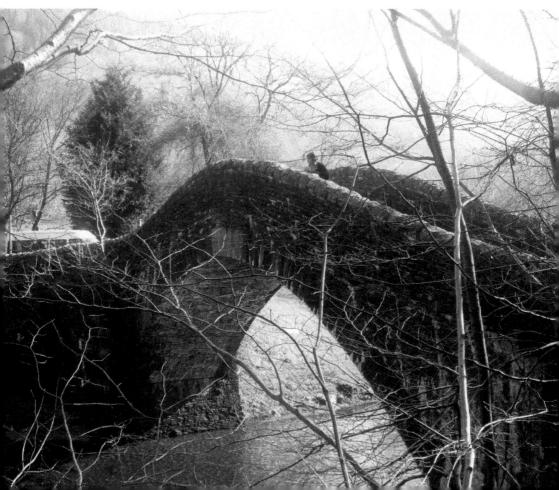

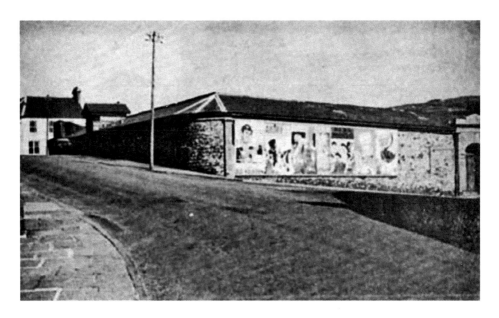

Dowlais Market Hall and Garden

Dowlais was once a thriving community and its residents had little need to visit the town centre. With its own shops, public houses and post offices, everything was on your doorstep, and there was even a market hall. It was designed by Edward Haycock of Shrewsbury and built in 1844. There were a variety of stalls, providing food, clothing, gambling and many other items. Unfortunately, due to the closure of the ironworks and the increase of mainstream shops opening in the town centre, Dowlais' shopping community slowly diminished. The market hall was demolished in the 1970s. The site of the old market today is practically unrecognisable. During the 1980s, the ground was used to create a garden and seating area for local residents.

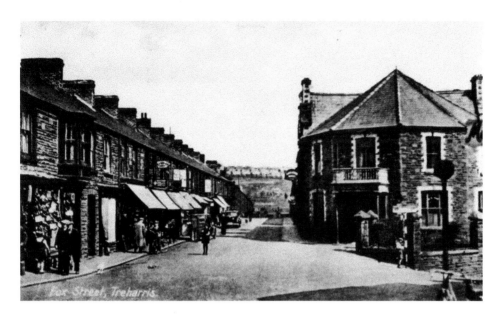

Navigation Hotel, Treharris

The Navigation Hotel was built and opened in 1878 by David Evan Jones, who was the landlord for some years. In the early days, the coal miners who worked at the Deep Navigation Colliery went to the hotel to get their wages. David Evan Jones invested a great deal in the development of the village and is believed to have built many cottages in the area. By 1891, John Aurelius had taken over the business. The Navigation Hotel has remained an open and well-attended public house with a number of different landlords in the intervening years. A large-scale regeneration project is now ongoing in the area. The Navigation Hotel is benefitting from this with work to improve the exterior of the building, to keep this historic building in excellent condition.

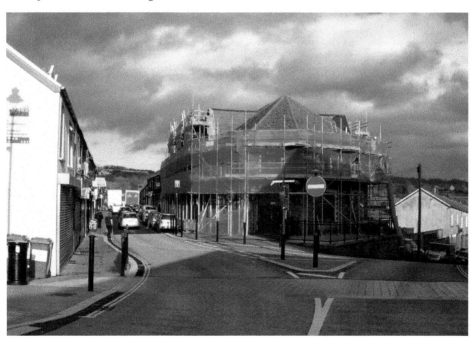

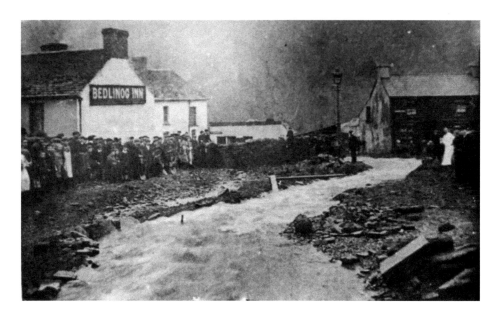

Bedlinog Inn

The Bedlinog Inn was one of the original buildings that made up the farming community of Cwmfelin. Opposite the inn was Salem chapel. The picture above, from the early 1900s, shows the shocked inhabitants of Bedlinog as floodwaters raced passed the inn and through their village. As a result of the heavy rainfall, a villager was drowned, despite rescue attempts. Up until recently, the inn was still in use as a public house. It has now been purchased and restored to its original fascia by local company Smerdon Tree Services. Once completed, the 'Old Inn' will be in use as a seven-room en suite bed and breakfast and restaurant, with an orangery eating area and gardens.

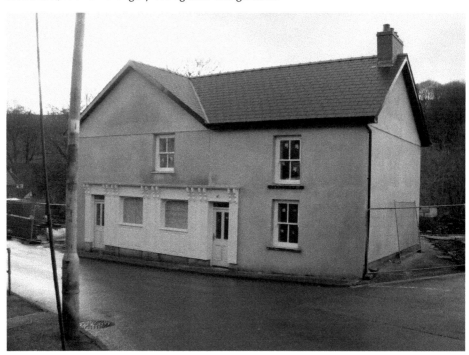

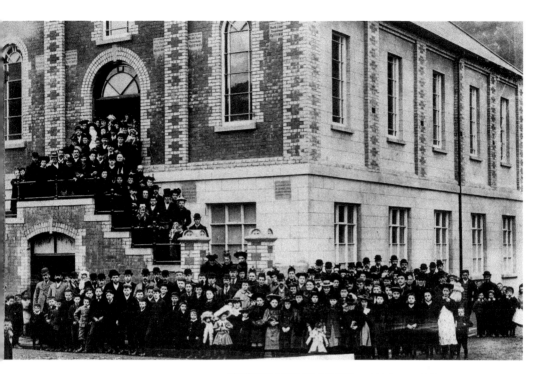

Tabernacle Chapel, Troedyrhiw

Tabernacle English Baptist chapel was purpose built to hold the growing congregation of Revd W. Thomas of Bethel chapel. The new chapel was built on vacant land at the top of Yew Street. A large hall was first built to hold 500–600 people, and then the new chapel was built over the top of the hall. The picture shows the eager congregation on the opening of the chapel on Sunday 27 October 1895. During the 1950s, the chapel was renovated and altered to suit the more modern way of life, making the chapel more accessible. However, in 2000, the congregation were given some unfortunate news. The building was structurally unsound, meaning that services could no longer be held there and the chapel was closed.

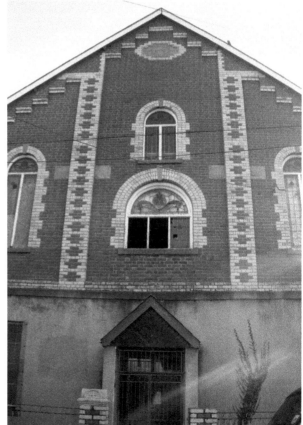

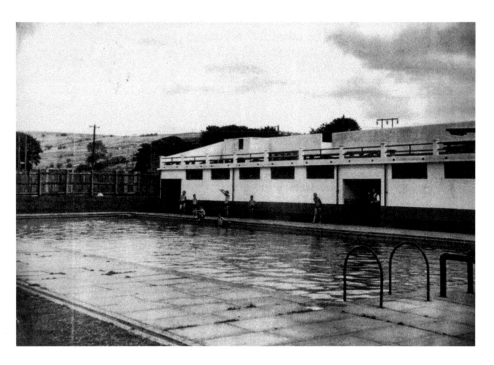

Pant Open-Air Swimming Baths

During the 1930s, a national campaign began to 'get the nation fit and healthy'. As a result of this, many open-air baths were opened across the country. In 1938, an open-air pool was opened in Pant. It was one of very few opened in such exposed areas. The children of Merthyr would have spent many happy days at the baths during the summer months. Unfortunately, due to new road layouts, the baths were demolished during the 1980s. The area where the baths once stood is now an area where children still play – albeit football rather than swimming!

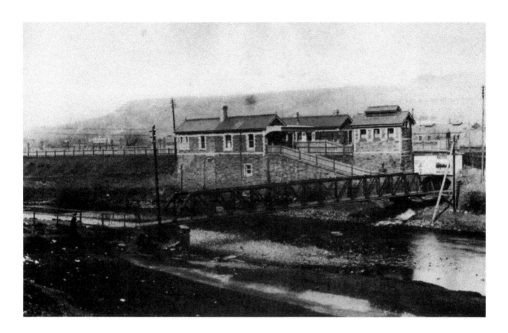

Pentrebach Railway Station

Pentrebach railway station was first opened by the Taff Vale Railway in 1886. The original purpose of the railway was to carry ore to Cardiff Docks. The station was part of a network of railways carrying the ore made at the different works to Cardiff Docks, where it was transported throughout the world. The photograph above is from around 1890. Pentrebach station is still in existence and forms part of the route from Cardiff to Merthyr. The trains that run there now are predominantly passenger trains, as the need for freight trains disappeared with the closure of heavy industry.

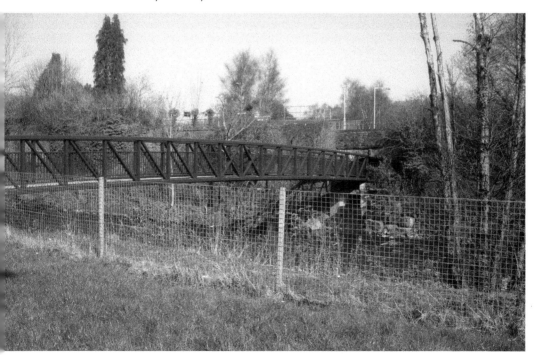

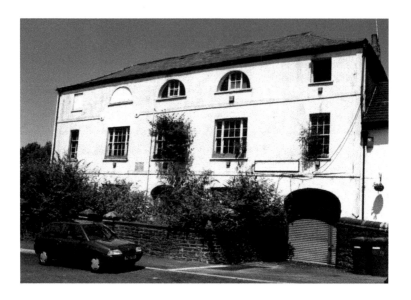

Vulcan House

The Vulcan House was built between 1820 and 1830. Here, David John, a blacksmith, mathematician and Unitarian minister, established a small iron foundry. David John and his sons were political reformists and were key figures in the first generation of Chartist leadership in Merthyr Tydfil. The house also held the Chartist printing press. During the 1840s, the Welsh-language paper *Trumpet of Wales* and an English-language Chartist news-sheet were printed here. During the twentieth century, there were some alterations and additions to the building. The Vulcan House stood derelict for many years and fell into a dire state. The site, owned by the council, was set for demolition due to the fact that the building was unstable, but luckily, with a partnership between Merthyr Tydfil County Borough Council and Wales & West Housing, a new proposal was put forward. A £2 million redevelopment programme began with financial assistance from the Welsh government in early 2012. Fifteen new flats were built and work finished in 2013. The area was renamed Vulcan Court. The scheme was officially opened by Huw Lewis Am and Cllr Brendan Toomey, leader of the council, on 24 January 2014.

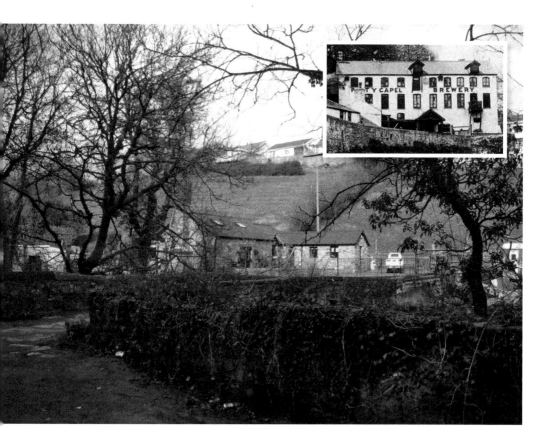

Pont-Y-Capel Brewery

Once described as 'the most picturesque in the kingdom', Pont-Y-Capel Brewery was founded by Robert Millar during the nineteenth century. Situated at the side of the River Taff, its water supply came from a spring further up the valley known as Ffynon Oer (Cold Fountain), and their power was initially provided by a waterwheel. The brewery was purchased from the Millar family by James Pearce during the 1860s. The company was improved considerably and, by 1871, was trading as Pearce & Shapton. Their ales were considered to be among the finest in the country. After the closure of the Cyfarthfa Ironworks, trading became increasingly difficult and, in 1921, the company closed. A new company took over the business called Cefn Viaduct Brewery, but this only lasted a few years, and it closed in 1925. Again, a new company was formed called the 'New Pont-Y-Capel Brewery' but ceased all trading during the 1930s. The Rhymney Brewery took over all its public houses.

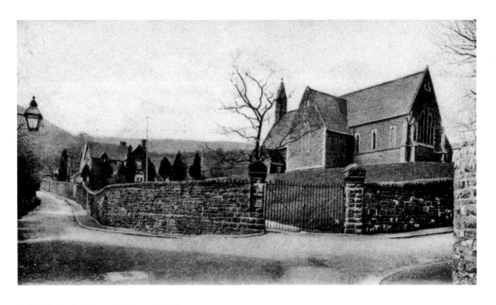

Saint John's Church, Troedyrhiw

The period 1850–53 saw the construction of St John's church by John Prichard. The church was commissioned and built for Anthony Hill of the Plymouth Ironworks. He insisted that only he should be buried within. The church served as a chapel of ease for Merthyr Tydfil (for those who could not reach the parish church conveniently), but became a parish church in 1860. When Anthony Hill died in 1862, his workmen were given the day off to attend his funeral. They each donated that day's pay to purchase the stained glass window on the east side of the church. The church and the window have undergone several repairs over the years, but it still holds regular services and is situated on its original ground.

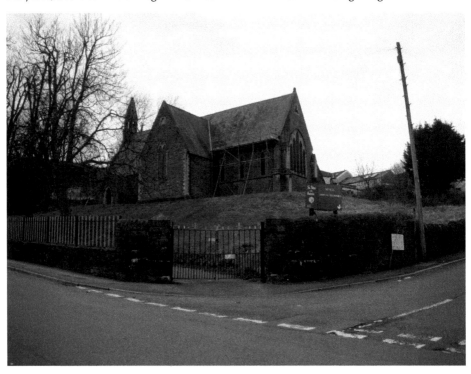

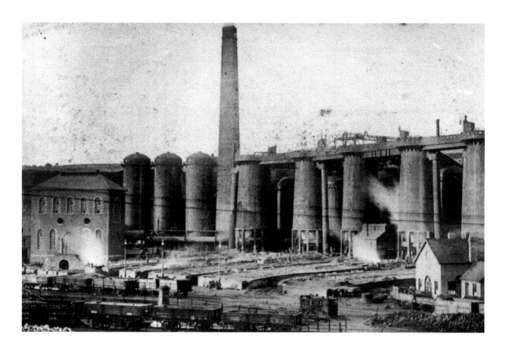

Cyfarthfa Ironworks

Pictured here are the blast furnaces of the Cyfarthfa Ironworks. Originally opened by Anthony Bacon in 1765, Richard Crawshay became a partner in 1777. Under Richard Crawshay, the ironworks became an important producer of iron products, especially in the building of cannon and other weapons for the various conflicts Great Britain was involved in. The ironworks passed through the Crawshay family from father to son. Robert Thompson Crawshay was the last of the great Crawshay ironmasters. Unfortunately, with the rising cost of the imported iron ore, and Robert's reluctance to switch to the production of steel, the works was forced to close. After his death, his sons reopened the works as a steelworks. The business continued until 1902, when the works was sold to GKN Ltd. The works closed for the final time in 1919. It fell into disrepair and was dismantled in 1928. Today, not much visibly remains of the Cyfarthfa Ironworks.

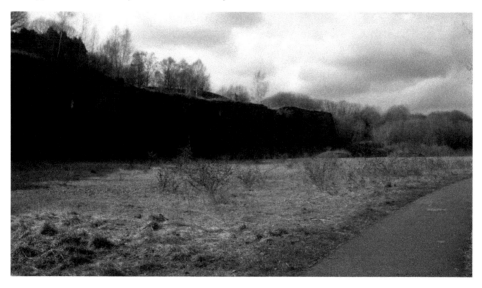

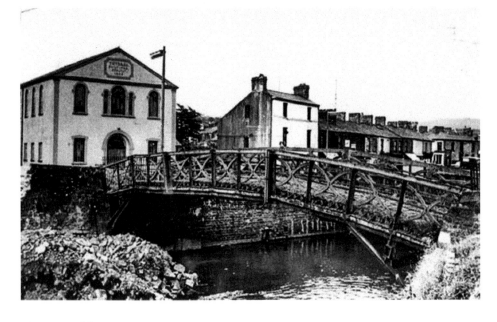

The Iron Bridge

Once known as the Merthyr Bridge, the Iron Bridge was built to replace a stone bridge that had fallen during 1795. Situated in front of Ynysgau chapel, the bridge was commissioned and paid for by Richard Crawshay and designed and built by Mr Watkin George. Mr George was the principal engineer at the Cyfarthfa Ironworks. Work began on the bridge in 1799 and work was completed in the mid-1800s. During 1879/80, a second bridge was built over the River Taff to cope with the amount of traffic crossing. The Iron Bridge was still used as a footbridge up until after the Second World War, but it was then fenced off at each end. It remained so until a decision was made by Merthyr Tydfil County Borough Council to remove the bridge in November 1963. The second bridge was replaced by a third bridge, this is the bridge we see today, and is situated where the original Iron Bridge once stood.

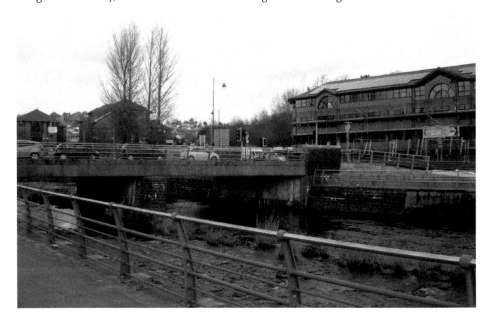

Castle Cinema and Penderyn Square

Built by local contractor G. Warlow and architect O. P. Bevan, the Castle Cinema opened its doors for the first time in 1929 on the site of the former Castle Hotel. During the 1930s, ownership passed to ABC Cinemas. The cinema housed one of the most splendid organs of its time and was placed in front of the screen that was lowered and raised as needed. The organ fell into disrepair and was removed in the 1950s. The cinema produced its own electricity from two oil engines in its basement. The first floor also housed a dance hall. ABC Cinemas owned the Castle Cinema until the 1970s, when ownership passed to the Leeds-based Star Group, who converted the stalls area into a bingo hall, and constructed two studio cinemas. The cinema then passed to a series of independent operators, and when bingo ceased, the hall was re-seated to create a new cinema screen. The cinema finally closed in September 2003. The building was converted into a skating rink, bowling alley and, finally, Studio Bar. The building was demolished in January 2011, and the area is now being regenerated as the Penderyn Square.

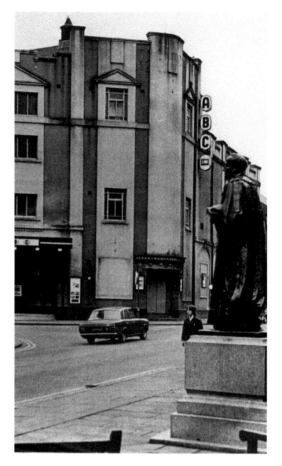

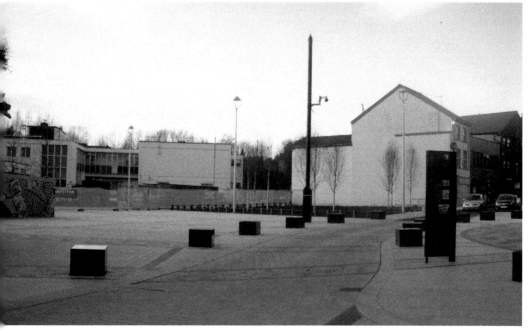

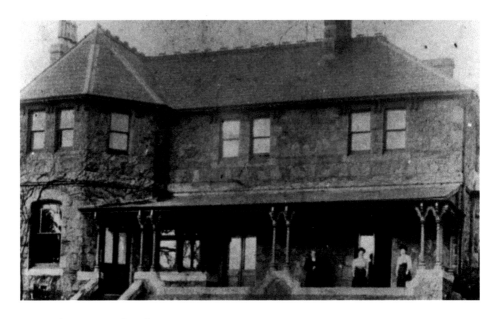

Bargoed House, Treharris

Bargoed House was built during the late nineteenth century behind St Mathias church. The 1901 census shows that the Ray family were living there. It is listed as a private dwelling with eight large rooms. Jacob Ray (head of the household) was the chief agent for the Ocean Collieries and moved to Treharris from Pontypool. Bargoed House was demolished during the 1960s, and the 'New' Bargoed House was built as a care home for the elderly by the council during the 1970s. This care home was then closed in 2010 and demolished in 2011. There were plans that the land might be used for a supermarket site, but a year later, during the summer of 2012, the rebuilding of a brand-new nursing home started, owned by Merthyr Valley Homes. The new home was completed and opened in 2013.

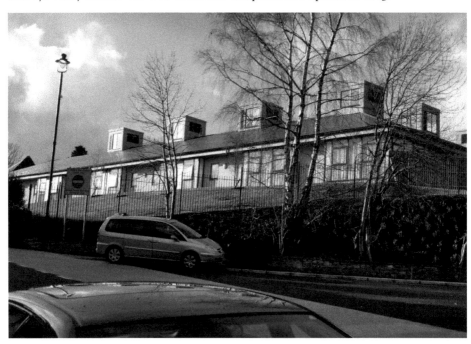

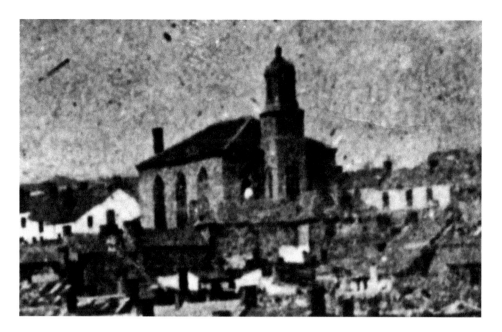

Saint John's Church, Dowlais

John Josiah Guest, the most successful ironmaster of his generation, funded the building of St John's church, Dowlais, in 1827, for the religious welfare of his workers. In November of that year, the church was consecrated by the then Bishop of Winchester. The original church was plain and simple, but over the years it underwent several changes and rebuildings. It was well known for its stained glass window, dedicated to the coal-mining industry – 'The Miners Window'. After the rebuilding, the church was able to seat around 800 people, which was perhaps too large for its congregation. The church was closed in 1997 after holding services for 170 years. In 2011, the BBC reported that, 'A Grade II listed church in Merthyr Tydfil with connections to the Dowlais Ironworks is to be developed into twenty apartments.' John Josiah Guest is buried within the church, and it was reported that if the plans go ahead, 'His tomb's memorial plaque, the chancel steps, a memorial mural and pulpit will be retained for the public to view.'

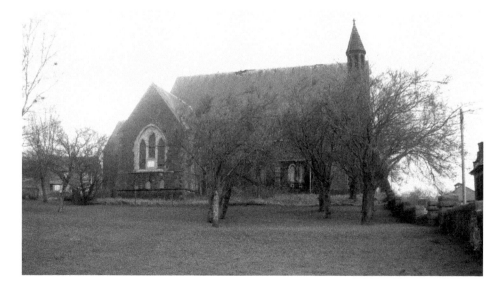

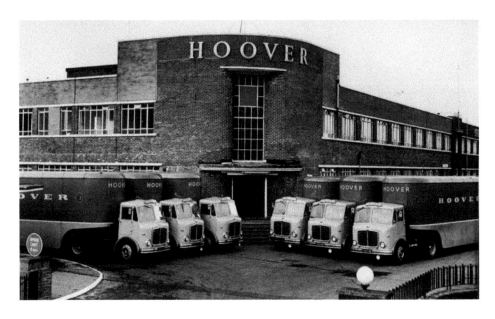

Hoover

Hoover Ltd of Canton, Ohio, USA, wished to expand their company into the UK. Land was available at a site in Pentrebach. The factory was purpose built and equipped to manufacture the Hoover electric washing machine. The Hoover (Washing Machines) Ltd factory was officially opened on 12 October 1948. Pictured above at the main gate is the Hoover transport department, with the AEC Mercury articulated lorries. At its height, the Hoover (Washing Machines) Ltd factory was the largest employer in the borough of Merthyr Tydfil. During the 1990s, the first mention of job cuts was announced. Nearly twenty years later, just after the company celebrated its diamond jubilee, it was announced that formal consultations would be going ahead on the future of the company. On the 13 May 2009, the Hoover factory ceased production.

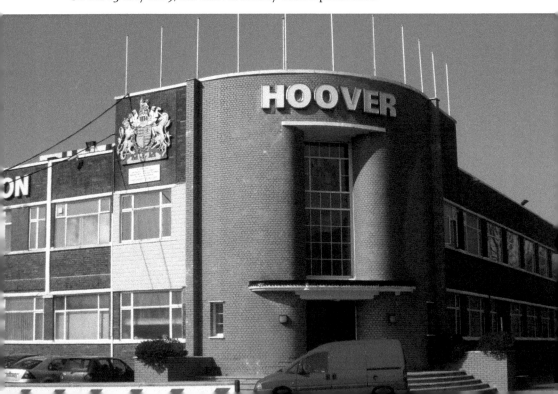

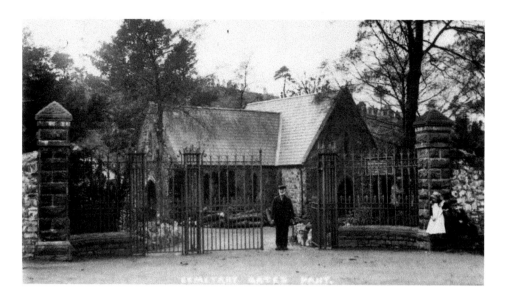

Pantysgallog Cemetery

One of the largest municipal cemeteries in the Merthyr area, Pantysgallog Cemetery, opened in 1849. It was originally opened for the victims of the second cholera epidemic to hit the town, which claimed the lives of 1,432 people. The existing parish cemetery around St John's church in Dowlais no longer had room for all the burials. Originally, separate areas were provided for different religions. The cemetery has remains in service until the present day. Very little has changed within the cemetery and it has been kept in a good state of repair. The trees and greenery have matured and provide a quiet and serene space for reflection.

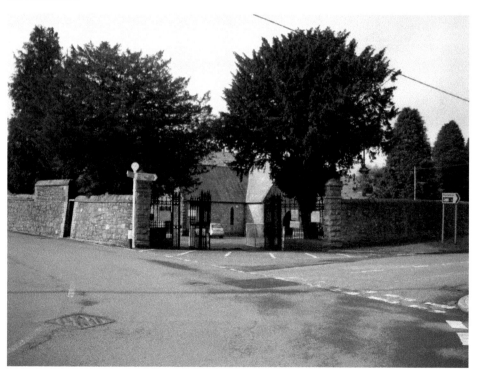

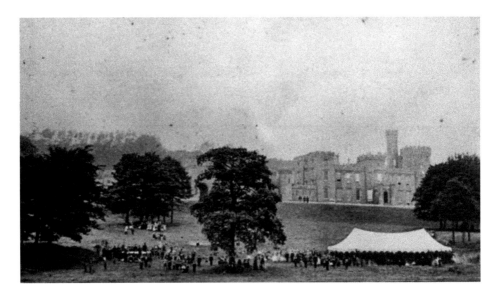

Cyfarthfa Castle and Grounds

Cyfarthfa Castle was planned by William Crawshay II, and designed by Richard Lugar. Work began on the 'castle' in 1824 and was completed in 1825 at a cost of £30,000. The castle originally covered an acre of land, and the grounds covered a much larger area. It had its own dairy, icehouse and brewhouse, and large cellars were used to store supplies and wines. The grounds themselves covered 18 acres of garden, lawns, greenhouses, lakes and outbuildings, with a further 142 acres of land adjacent for farming and woodland. Cyfarthfa Castle was home to the Crawshay family until 1889, when William IV left Merthyr. The castle stood unoccupied until 1900, when it was purchased by Merthyr Tydfil Corporation. The castle was then converted into a grammar school and museum and its grounds opened as a public park, which it remains today. In recent years, the museum and grounds have undergone refurbishment but they still retain their splendour.

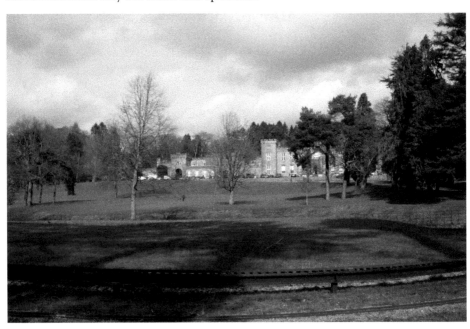

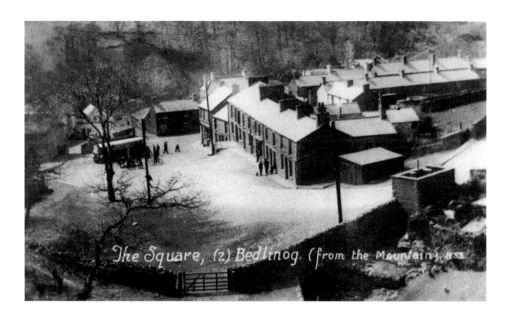

The Square, Bedlinog

Prior to the sinking of the collieries during the 1870s, Bedlinog was a small hill farming community. It was triangular in shape and had three separate communities. One of these was Cwmfelin, which translates to Valley of the Mill. As the community grew around Salem Chapel (built in 1840), the village square soon appeared where all local markets were held. Bedlinog Square looks practically the same today as it did in the 1870s. The square is no longer used as a focal point of the community, with the loss of local markets due to the rise of supermarkets, but the cenotaph still remains and the people of Bedlinog remember their dead, and hold services on Remembrance Sunday.

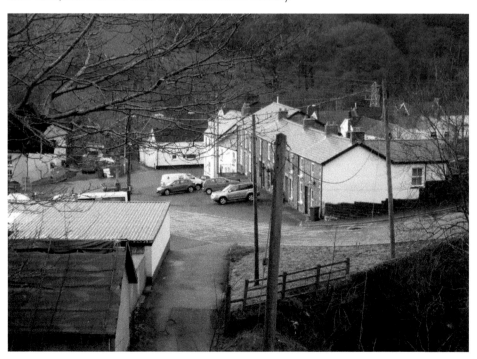

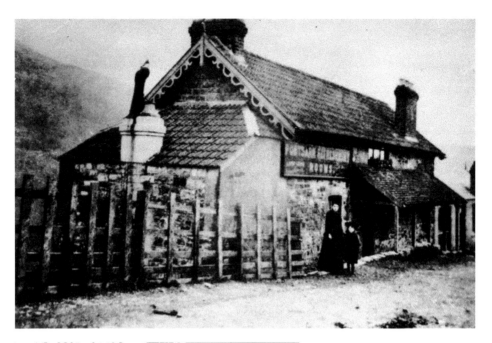

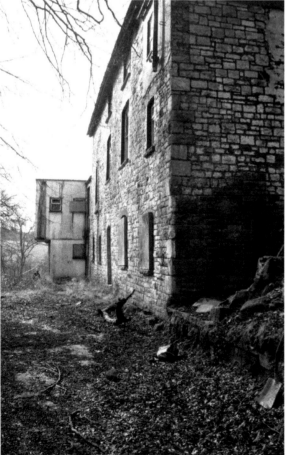

Pontsarn Refreshment Rooms and Hotel

During the nineteenth and twentieth centuries, Pontsarn had become a popular destination for families wishing to leave the town and spend some time in the country. Not far from the Pontsarn railway station, the Pontsarn Refreshment Rooms opened to take advantage of the influx of people visiting the area. They had a quoit ground, a small park with swings for children, and also sold tickets for trout fishing. The rooms also catered for lunch and tea parties. Although the tea rooms are no longer in existence, Pontsarn is still an Area of Outstanding Natural Beauty, with the Taff Trail providing easy access on foot from Merthyr Tydfil. Pontsarn is the entrance to the National Park, an area of 519 square miles.

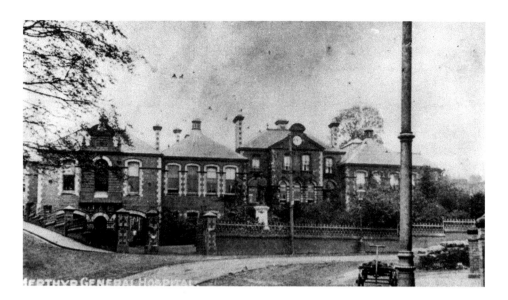

General Hospital

The original building of Merthyr General Hospital was designed by Mr T. C. Wakeley and erected by Messrs Bowen of Abergavenny. In 1886, the First Lord of Merthyr, Sir W. T. Lewis, on behalf of the Marquis of Bute, offered money towards the erection and endowment of the hospital. The hospital was officially opened by the Marquis of Bute on 22 October 1888. The workmen of the local ironworks, coal mines, railways and local government paid a weekly subscription to the funds of the hospital. Outside of the hospital is a statue of Sir W. T. Lewis. Since the 1920s, the General Hospital has undergone several refurbishments and reconstructions. In 1925, the hospital was accepted and approved by the General Nursing Council as a training school. Funds were raised over the years for extra nursing accommodation and extensions to the paediatric unit. By the 1980s, the General Hospital was up for sale and its future was uncertain, as the council had dismissed the building, having no use for the old hospital. By the end of 1986, it was sold to the Abergavenny-based Rosenberg Organisation, who converted it into a nursing home. The maternity wing remained open until the new wing was built at Prince Charles Hospital. The building has sat derelict since the nursing home closed in the 1990s.

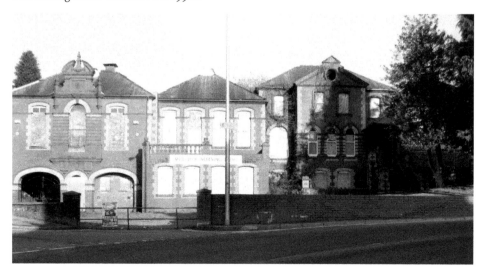

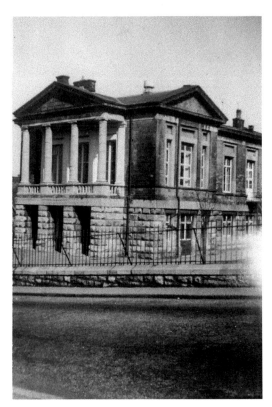

Guest Memorial Library and Guest Keen Club

The Guest Memorial Library and Reading Room was built on the commission of Lady Charlotte Guest in memory of her husband, Sir Josiah John Guest. Designed by Charles Berry, work began in 1855, and was originally paid for by the Dowlais workmen at a cost of £2,200. But as costs began to exceed the money available, the Dowlais Iron Company took over the completion of the building on the condition that it became their property. The library eventually opened in 1863 at a final cost of £7,000. After serving the public for many years, the Guest Keen Memorial Library is now a privately owned building and is run as a successful club. The building is Grade II listed, and has been sympathetically renovated to provide a lovely venue for special events such as weddings, with the Lady Guest Suite licensed for civil ceremonies.

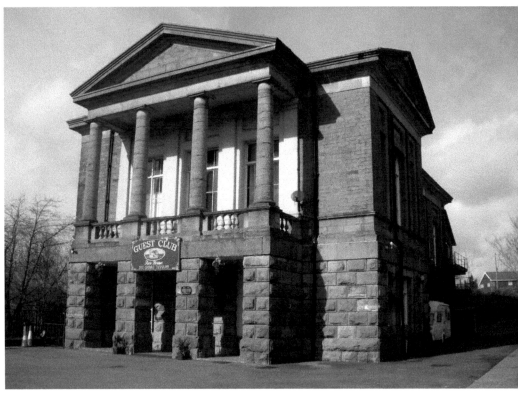

Gurnos Farm

Linked to the Cyfarthfa Ironworks, Gurnos Farm was once the largest farm in the borough of Merthyr Tydfil. The land had a number of farm cottages and a mill with a stream, and also contained a large, wooded area. A succession of farmers lived at the farmhouse, managing the land for the ironmasters and supplying Cyfarthfa Castle with fresh foods, meat, eggs and milk. At the beginning of the twentieth century, the farm was owned by Lord Buckland; however, during 1923, he began selling his stock and gave up farming. By the 1950s, Thomas Parry was farming the land and he bred award-winning Welsh Mountain ponies until the 1970s. The area was the largest stretch of uncontaminated land in the borough, and so during the early 1950s much of what was farmland was converted into the Gurnos housing estate.

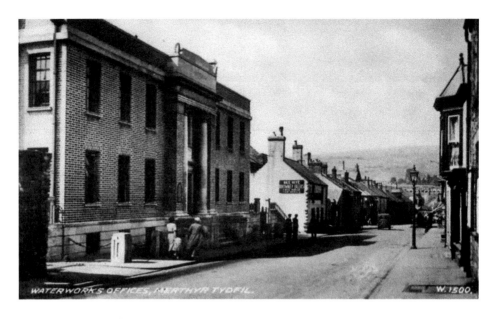

Castle Street, Merthyr Tydfil

Pictured above is a shot of Castle Street in 1938. The prominent building on the left-hand side was built in 1932 for the public sector, and was used by the Taff Fechan Water Board. In 1973, the Water Board became part of the Welsh National Development Authority. In the distance is the Beehive public house, which dates back to the 1840s. The view of Castle Street today would be unrecognisable if not for the Water Board building. Although the building itself has not changed, the Water Board was privatised in 1974, becoming Welsh Water. They moved from the building and social services claimed it. The Beehive was demolished in 1967, but has been replaced by The Winchester public house. What dominates the skyline most is the new Castle Hotel, which was built on the site of the old Co-op in the 1970s.

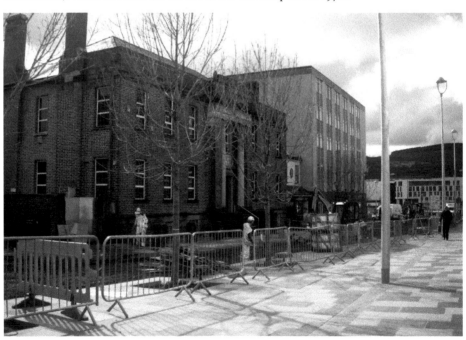

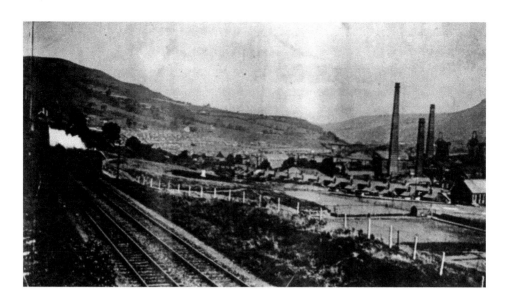

Merthyr Vale Railway Station

Merthyr Vale railway station was first opened in 1883 by the Taff Vale Railway (TVR). The TVR is one of the oldest lines in South Wales. It operated as an independent company from 1836 until 1922, carrying freight and passengers around the South Wales valleys. It then merged with the Great Western Railway. The station was briefly shown in Richard Fleischer's 1971 film, *10 Rillington Place*. Until the 1960s, there was a vast network of train links connecting all villages and towns in the South Wales valleys. The infamous Dr Beeching closed many of these links. Fortunately, the Merthyr to Cardiff line survived the closures. The station today still exists, although greatly changed in appearance, and serves the population of Aberfan and Merthyr Vale.

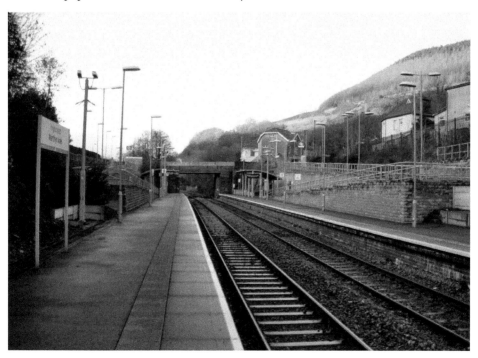

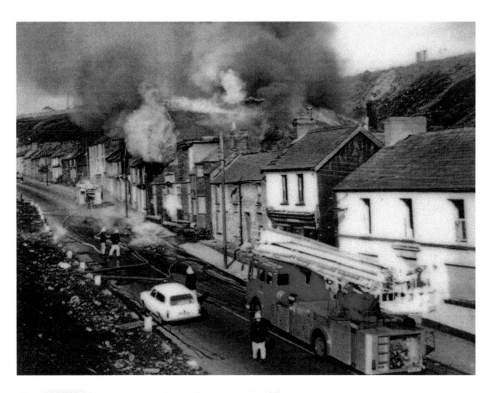

Radcliffe Hall, Penydarren and Penydarren High Street

Radcliffe Hall chapel was built by members of Hermon and Libanus chapels. The hall was officially opened on Good Friday 1905. The hall was named after Henry Radcliffe, who was originally from Dowlais and owned a shipping company in Cardiff. He made a substantial contribution to the building costs of the chapel. It was originally a Welsh chapel but, by 1908, it became an English cause. Radcliffe Hall closed its doors in the 1970s and was then used as storage for a furniture removal company. Radcliffe Hall was set back from the road, but was destroyed by a fire during the 1980s. Once a busy street, the buildings have now all but gone and the area has remained an open space. The road is the main High Street off Penydarren and is a busy thoroughfare for traffic and walkers. It has changed completely from its original use.

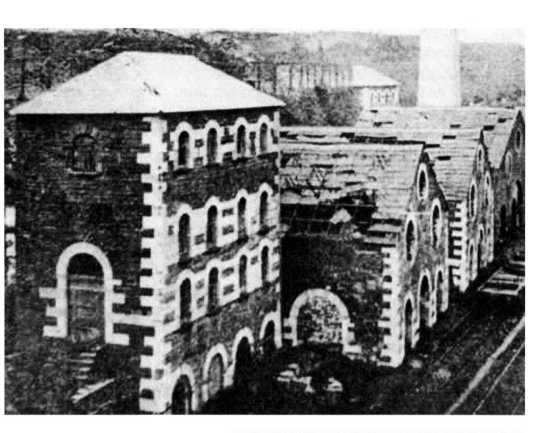

Ynysfach Ironworks and Engine House

The Ynysfach Ironworks were built in the early nineteenth century, when two blast furnaces were built. In 1836, two more blast furnaces were built, along with the Engine House, which replaced an earlier one at this site. The new Engine House contained the beam engine for the blast furnaces. Ynysfach Engine House forms part of the rich heritage of Merthyr Tydfil. It has been renovated sympathetically and is now one of the many heritage tourist attractions in the town. A number of heritage activities now take place here with interactive displays and walks.

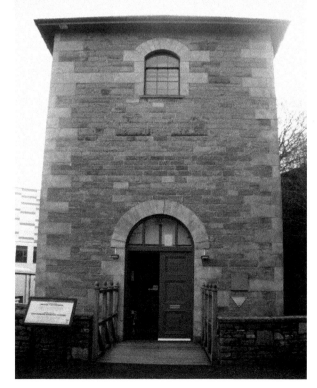

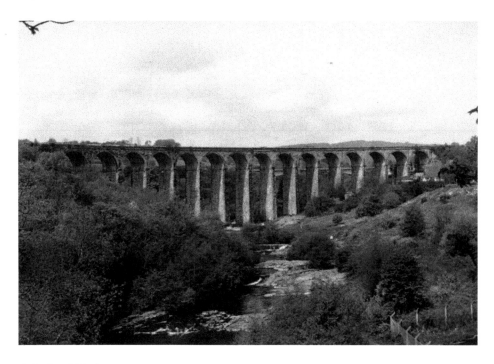

Cefn Coed Viaduct

The Cefn Coed Viaduct was built in 1866. Designed by a friend of Robert Thompson Crawshay, A. Sutherland, and built by Messrs Savel & Ward, the bridge was erected at a cost of £25,000. The viaduct was purpose built to carry the Brecon to Merthyr Railway across the River Taff at Pontycapel. It was built with a curving sweep so as to avoid the Crawshays' land. The line over the viaduct was finally closed to passengers in 1961, although goods services continued until August 1966. During the 1970s, the viaduct was threatened with demolition due to high maintenance costs. After lengthy discussions, many petitions and correspondence from the Heritage Society, the bridge was finally designated Grade II listed building status. The viaduct still stands and is the third longest in Wales. Today, it forms part of the Taff Trail footpath.

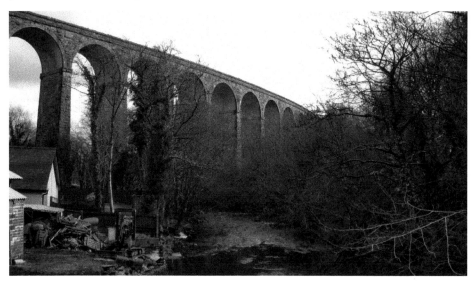

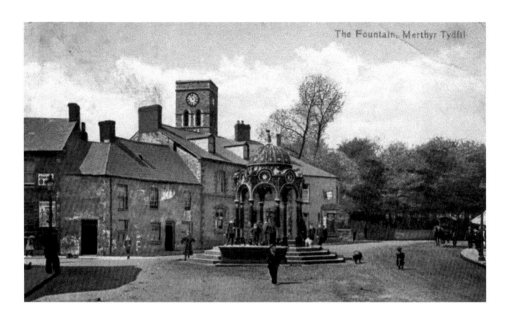

The Fountain

The fountain was a given as a gift to the people of Merthyr Tydfil by Lord Merthyr, Sir W. T. Lewis, in 1906. It was dedicated to the captains of industry from the area, including his grandparents, Robert and Lucy Thomas. The fountain was originally painted black and gold and had iron mugs on chains present for thirsty passers-by. Due to town redevelopment plans, the fountain has been moved several times over the years, but has thankfully survived. Moved during 1968, it became a focal point for the Caedraw flats, placed just in front of St John's church. It was moved once again in 1996 to its current position at the entrance to the town. At some point, the fountain was painted green, but for the official opening on Thursday 18 July, the fountain was restored to its original colour of black and gold. Where the fountain originally stood is now the main road from Merthyr.

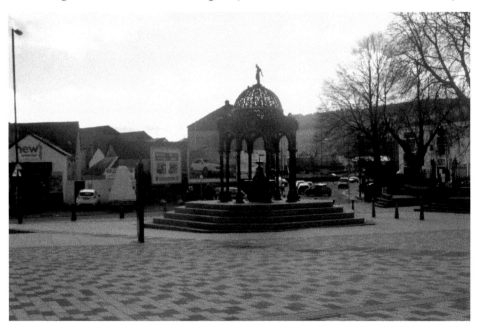

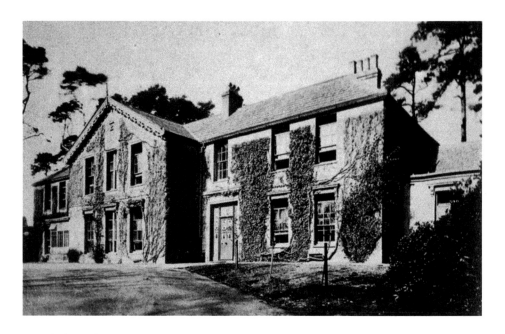

Gwaelodygarth House

Gwaelodygarth House was built during the nineteenth century, originally for the Crawshay family. While Cyfarthfa Castle was being built, William Crawshay II lived at the house. It was situated on the edge of the Cyfarthfa Estate, and stood in its own grounds surrounded by farmland. The house was home to the Berry family in 1912 until it was sold to the GKN. Since the mid- to late twentieth century, the house has been used for many things. The house was converted into a domestic training institution and, during the Second World War, was a school for female evacuees. During the 1950s, the house was opened as a training school for nurses, and then in 1979 as a mental health day unit. Although empty in more recent years, the house remained in a reasonably good condition until a fire broke out in 2003 and destroyed part of the building. In order to ensure the restoration of the property, the land was developed into a housing site, Cyfarthfa Court.

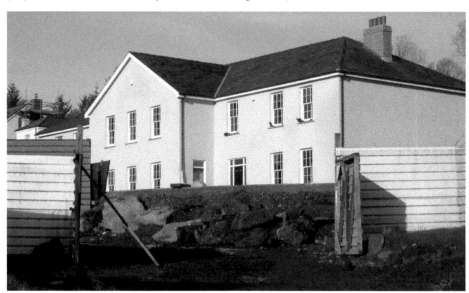

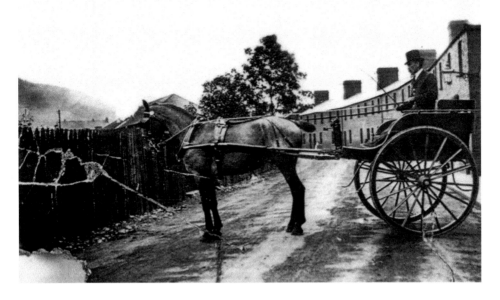

Nixonville

In 1869, John Nixon started the development of the Taff Vale Colliery, later to be known as the Merthyr Vale Colliery. In order to house the miners and their families, the community of Nixonville grew. The picture shows the carriage of the collieries' doctor, Dr Charles Richardson White, and his driver, J. Adams. During the 1960s, the Merthyr Vale Colliery had a £2 million reorganisation, involving electrification of winding engines, loading facilities, new underground systems and other modernisation. Unfortunately, this did not save the colliery and it closed on 25 August 1989. Even with the closure of the colliery, Nixonville is still as recognisable as it was during the twentieth century, with its long row of houses.

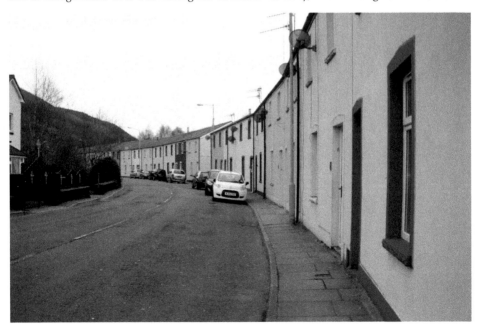

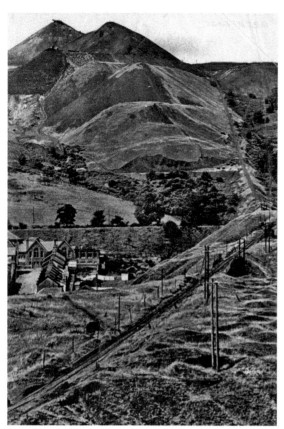

Pantglas School
A view of the Taff Merthyr Colliery tip in Aberfan. At the forefront of the photograph to the left, you can clearly see the tramlines used to take the waste from the colliery to the top of the mountain. On the left of the photograph, at the bottom of the mountain, is Pantglas School, built sometime between 1901 and 1922. On 21 October 1966, the most catastrophic collapse of a colliery spoil tip descended on the village of Aberfan. The mountain and rubble spilled down, covering the school and nearby houses. Twenty-eight adults and 166 children were killed. After the disaster, a fund was created receiving money from over forty different countries. The money was used in numerous ways, including respite breaks for families, the construction of the Aberfan & Merthyr Vale Community Centre and, on the former site of the school, a public memorial garden.

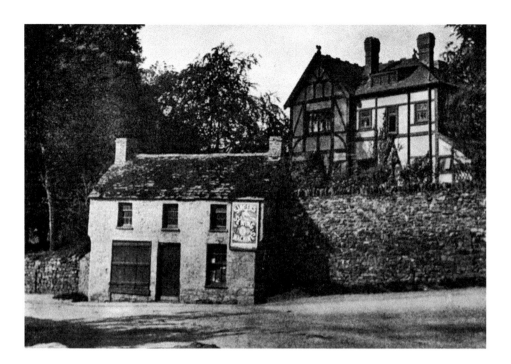

The Old Toll House

Toll houses were built from as early as the seventeenth century throughout England and Wales in order to collect road tolls to maintain principal roads. Until the mid-nineteenth century, the Pandy Farm was used to extract revenue from travellers and farmers bringing their livestock and produce to sell in the town. In 1842, a new toll house, also known as the Round House, was established. With the coming of railways and then the Local Government Act of 1888, the need for toll houses began to decline. The act, which established county councils and county borough councils, also passed the responsibility for maintaining main roads on to these new authorities. May toll houses were demolished but several hundred survived, one of which is the Old Toll House on Brecon Road.

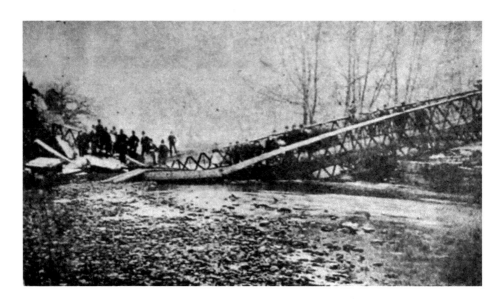

Pontyrhun, Troedyrhiw

Pontyrhun (Rhun's Bridge) is so called as it reputedly marks the spot where Rhun, son of Brychan, was killed defending his sister Tudful and other family members from a horde of Picts. The original bridge would have been made of wood and is listed as early as 1540. By 1820, the bridge was replaced by a stone bridge. During the winter months, it suffered much damage and had to be repaired and rebuilt several times. Pictured above is the bridge after its collapse on 15 December 1878. The bridge was reconstructed in 1880 using most of the iron from the previous bridge. The bridge stayed the same until 1945, when plans were put into place for a new bridge. Nothing was done until the 1960s, when it became apparent that the bridge was no longer suitable for modern-day vehicles. The bridge was closed in the mid-1960s, when the new bridge, which still stands today, was built.

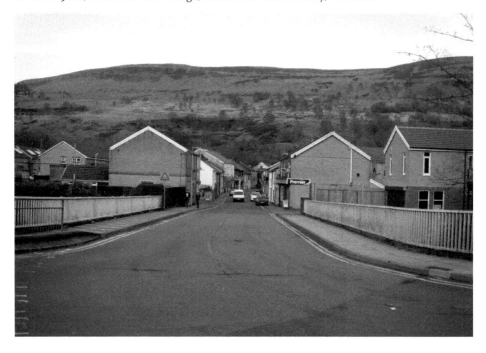

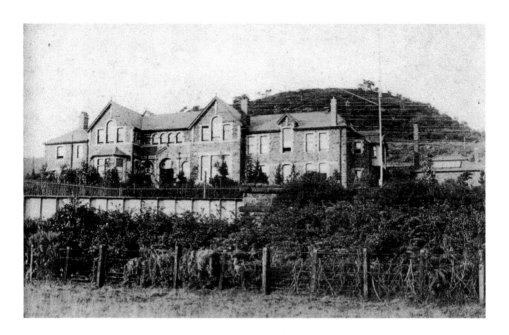

Edwardsville Truant School

During 1870, school attendance and its enforcement became compulsory. This proved to be a problem for many who were not used to this type of discipline. The Edwardsville Truant School, also known as a training school, was built in 1893, and took in boys from all over South Wales and Monmouthshire. The school was intended to take in the boys who were roaming the streets. Parents had to pay a weekly amount for maintenance of their children. These schools were never used for girls. During the 1960s and 1970s, the school was converted into a residential care home. Later, it was demolished to make way for the Taff Vale Estate, which provided much-needed housing at the lower end of the valley. The estate, like many other parts of the lower valley, suffered from subsidence as a result of the mining in the area. The Coal Board paid large amounts of compensation out to residents and the houses are now safe and secure.

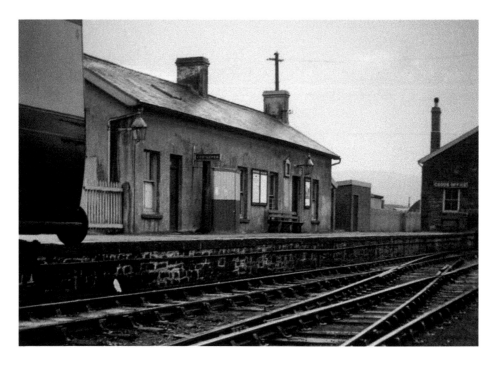

Dowlais Central Station and Dowlais Community Centre

As early as 1836, John Josiah Guest of the Dowlais Ironworks had written a proposal to construct a railway linking Dowlais to the valley of the River Usk. It wasn't until 1869 that the Brecon & Merthyr Railway network opened Dowlais Central station. It was once known as Dowlais Lloyd Street station, but was locally known as Dowlais Tip station. It was opened to serve passengers as well as for industrial use. The Dowlais Central station closed to passengers during the 1960s, but continued to traffic goods until 1964. The old engine shed and ticket office were restored and now serve the Dowlais community as recreational and community centres.

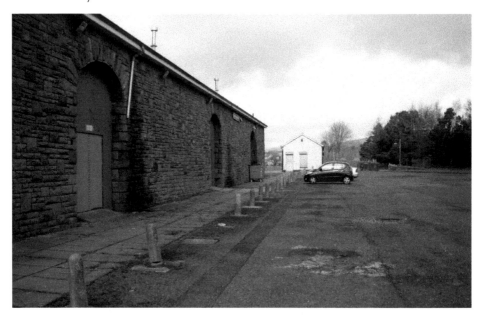

Shiloh Chapel and Miners' Hall

Designed by I. K. Brunel, on the instructions and financing from the Welsh Wesleyan Methodists, Shiloh was built in 1853. During the 1920s, the flock diminished, which left insufficient funds to repair and maintain the building. After many a discussion, ownership passed to the Miners' Welfare Organisation. Along with politically themed gatherings, the hall was also used to hold a variety of events for the public, including school gymnastics, auctions, dance classes, wedding receptions and many more. Eventually, the Miners' became the Miners' Welfare Club and obtained the appropriate licenses to ensure bingo could be played on the premises. After the demise of mining in the Merthyr area there was no real need for the Miners' Welfare Club, the building slowly started to show signs of neglect. During the late 1980s, the hall was bought and turned into a nightclub, but unfortunately it was ruined by a fire. The building once again fell into the same state of disrepair. Stonework and sections of the façade have lost quite a degree of cement and mortar, paintwork is peeling and grass grows freely.

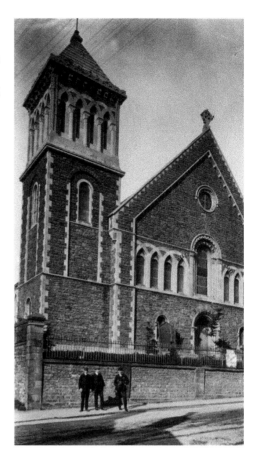

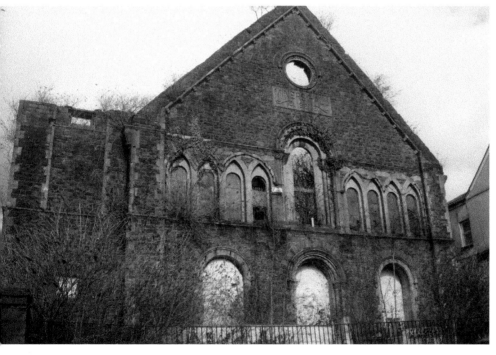

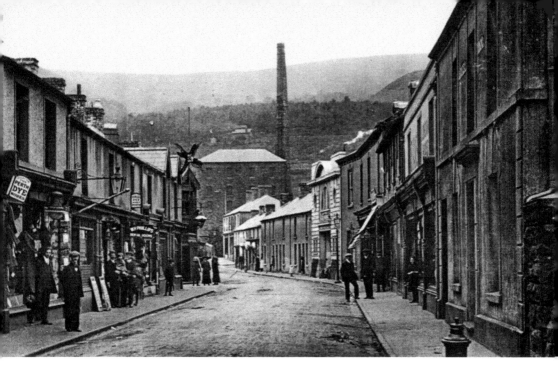

Bridge Street, Troedyrhiw

Looking up Bridge Street above, on the left-hand side of the road is the Picture Palace cinema. The cinema opened sometime during the 1920s or 1930s. At the end of the road is the pumping house that was used to top up the Glamorganshire Canal from the River Taff. Today, Bridge Street doesn't look so different from how it did during the 1930s. The Picture Palace, which was operated independently, was closed by 1963 and replaced by housing and local shops. When the pumping house was demolished, the land lay as wasteland until two new modern houses were built on the site.

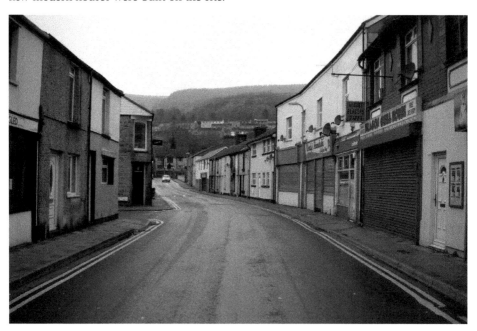

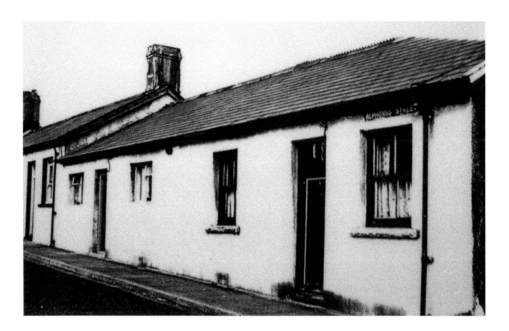

Alphonso Street, Penywern

The village of Penywern was originally built in 1839 for the workers of the Ivor Works. Before the housing was built, there wasn't much in the area save for barracks for the soldiers stationed to keep an eye on the town. Dowlais Iron Company started to import iron ore from Spain, and so a large Spanish community began to form in the area. Alphonso Street was named after Alphonso XIII of Spain, and was built to house the Spanish immigrants. Merthyr Tydfil has a long history of welcoming migrant workers from all over the world. The Spanish have left Merthyr now; however, recent years have seen large numbers of Polish and Portuguese workers coming to the area. New cultures, customs and practices have brought positive influence to a diverse cultural base and only add to the rich diversity that has made Merthyr Tydfil into what it is today.

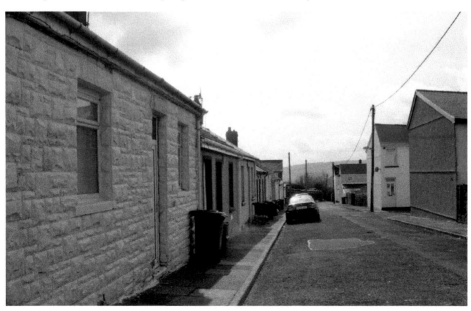

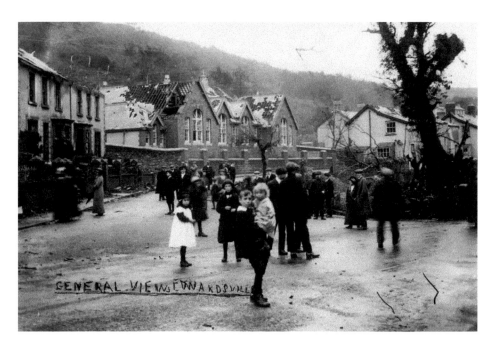

Edwardsville School

Pictured above is Edwardsville School after the tornado of 27 October 1913. Many buildings were destroyed along with the school, including houses and a chapel. Over 100 people were injured and three people were killed, making it the highest death toll in Britain from a tornado. During the 1920s and 1930s, the area was the location of three important educational institutions: Quakers Yard Grammar School (built in 1922), the Mining Institute (built in 1929) and Quakers Yard Technical School (built in 1937). During the 1950s, the grammar and technical schools amalgamated and stayed open until 1967. They were then replaced by the new modern secondary school in Troedyrhiw, Afon Taf High School. The current Edwardsville Primary School is now situated in the yard of the old schools. The school was built in 1975 and serves the villages of Edwardsville, Quakers Yard and Treharris.

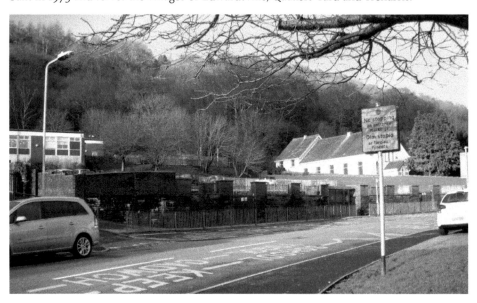

Williams' Memorial, Penydarren

During the twentieth century, the population at Penydarren soared. It was decided that an English Independent chapel would be built and a committee was formed for the new church. Firstly, a Sunday school was established in 1902, and a year later the first church service was held. Discussions began about building a new church building, but it wasn't until 1906 that the work began. The chapel was finally finished and officially opened at the end of 1916. The Williams Memorial chapel was demolished, and where it once stood there is now a small development of houses called Marks Court. With its proximity to Cardiff, Merthyr Tydfil has started to become an area sought after by commuters, and small-scale developments such as these are now more commonplace.

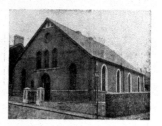

WILLIAMS' MEMORIAL
Congregational Church
Penydarren
(Founded 1903)

✠

ANNUAL REPORT
FOR 1962

The Church is Registered for the Solemnization of Marriages.

The Secretary would be very grateful to receive information concerning serious illness or bereavement in the families of Church Members and Sunday School Scholars. Arrangements may always be made for Private Communion and the visit of an Ordained Minister when required.

Further information may be obtained from the Secretary at 7 Awelfryn, Penydarren.

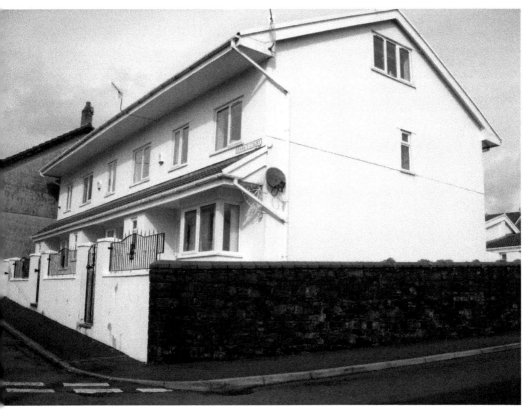

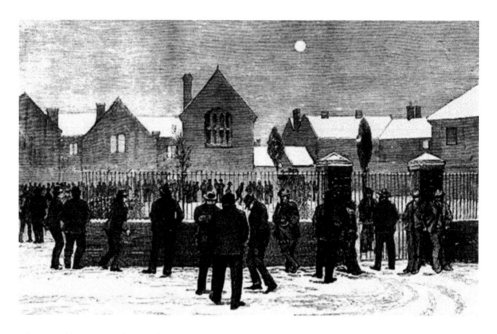

The Workhouse and St Tydfil's Hospital

In 1834, a new Poor Law was introduced, which ensured that the poor were housed in workhouses, and clothed and fed. In return, all workhouse paupers would have to work for several hours each day. Merthyr Tydfil was one of a number of areas that showed resistance to this new law and the erection of workhouses. It was not until 1853 that the Thomas Street workhouse opened. The workhouse also had an infirmary and maternity ward. In 1948, the workhouse became the responsibility of the County Borough and became a National Health Service hospital under the name of St Tydfil's Hospital. It eventually had seven wards, psychiatric intensive care units, and a medical rehabilitation ward. The hospital served Merthyr until the new Keir Hardie Health Park opened on the Georgetown Plateau, with services moving to the newer building with modern-day facilities. The old hospital currently sits derelict.

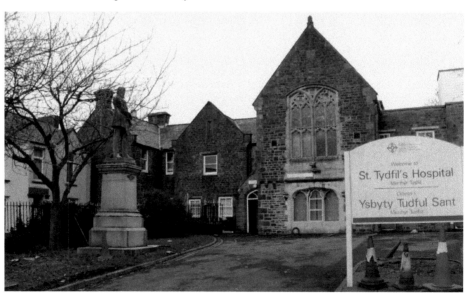

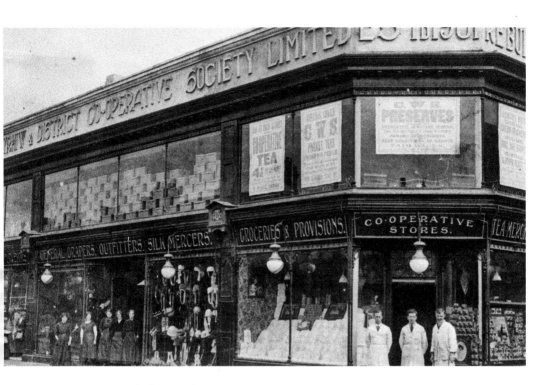

Co-op Stores, Troedyrhiw, and Costcutter

The Co-operative stores were set up to help the working class, and once boasted that they were the only organisation to share its profits with their customers. Merthyr Tydfil was once home to many Co-ops, which were all part of the large national organisation. Troedyrhiw's very own Co-op was opened in 1901 and it was later rebuilt in 1914. It offered everything from food and cleaning supplies to a bakehouse and other specialist departments. The Co-op closed its doors to customers in 1983. This was met by many protests from the people of Troedyrhiw, who used the store daily. However, the store has been in constant use by a variety of proprietors over the intervening years. A very recent renovation to the store has extended services and now provides the village post office as well as a handy convenience store.

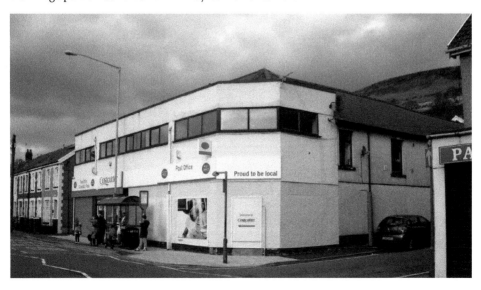

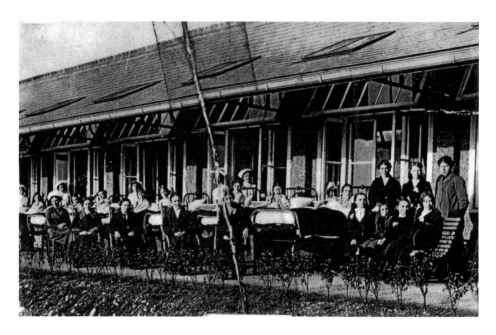

The Sanatorium, Pontsarn

During the nineteenth century, Merthyr was one of the fastest growing towns in South Wales. Due to the iron industry, many people moved here for employment. This meant that tightly packed, low-quality housing was erected. With so much overcrowding and insanitary conditions, the town became a breeding ground for disease. In response to this, a new hospital was built in the early twentieth century. The Sanatorium in Pontsarn was built in 1913 as a tuberculosis hospital. The site was chosen for its sheltered position where during the summer months the patients were brought out into the fresh air. Today only the central block survives. This block has been tastefully renovated and converted into flats.

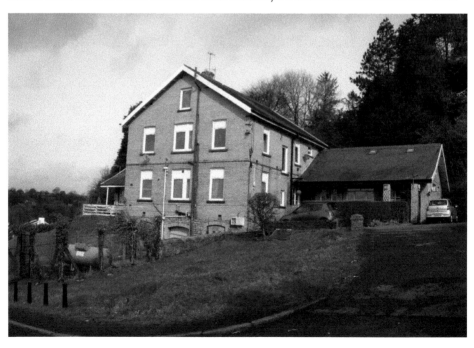

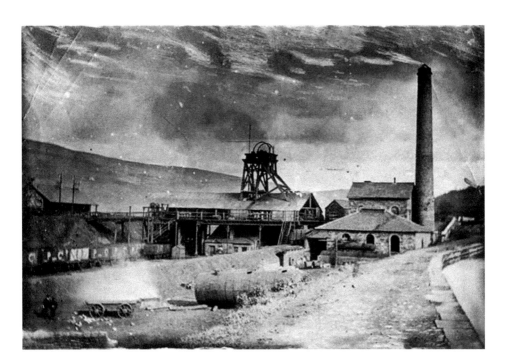

Abercanaid and Gethin Collieries

The village of Abercanaid mainly developed during the 1800s in order to sustain the collieries nearby. The first colliery to open was the Waun Wilt Colliery in 1824. It was later renamed the Abercanaid Colliery. The second, Gethin Colliery, was located on the canal, and was sunk in 1849. First owned by David Williams, the company was sold on to the Crawshays in 1865. Soon, William Crawshay sold the business to the Plymouth Iron Company. A fire at the colliery in 1873 resulted in its closure, and it wasn't reopened until late in 1884. The colliery suffered many more disasters, including a gas explosion that caused several fatalities. In the years between 1884 and 1899, thirty-three fatal accidents were recorded. Abercanaid Colliery was the first colliery to have underground electric haulage installed. Unfortunately, the colliery was unprofitable and so it closed in the early 1900s. Today, the Taff Trail runs alongside the area where the collieries would have once been so prominent a feature.

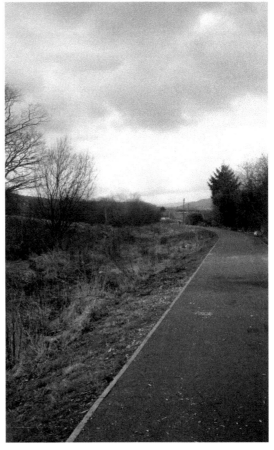

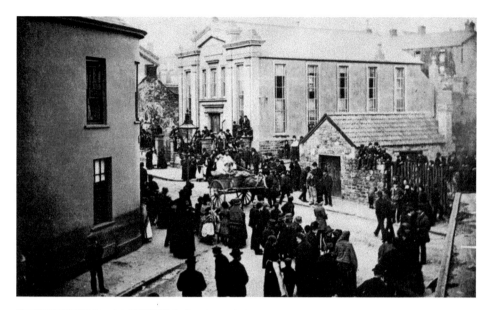

Hope Chapel

During the nineteenth century, there was an influx of people moving to Merthyr hoping to find employment within the collieries and mines. With a growing English-speaking population moving into the Merthyr town, members of the Pontmorlais chapel decided that an English-speaking chapel was needed. In 1861, Hope chapel was opened. The congregation grew so large that the chapel was no longer big enough to hold all its members. In 1893, the chapel was rebuilt, with the Memorial Hall added in 1911. During the 1970s, the chapel joined with Market Square and Trinity chapel to become a United Reformed Church. The rebuilt church of 1893 is what we see today, still in use and an important part of the community.

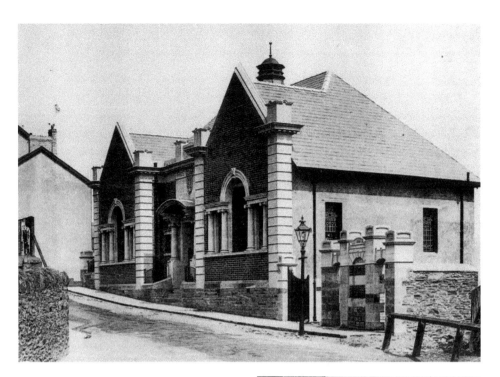

Treharris Library

In 1905, Pantannas Estate donated a site in Perrot Street to the library committee for a new library to be built. By 1906, the committee put out a tender for designs for the new Free Library. The library was officially opened by the Mayor Alderman Andrew Wilson on 20 October 1909. Thousands of people attended the opening ceremony and it was reported that the area was so tightly packed with people that a woman fainted. Over 100 years on and the Treharris Library is still open and serving the public. In 2009, it celebrated its centenary with cake, a buffet, photograph displays, the restoration of the clock on the outside of the building and staff getting dressed up and playing the role of schoolchildren from the early twentieth century. In 2013, the library was granted funding from CyMAL for the refurbishment of the interior. Treharris Library closed its doors to the public at the end of 2013 for the refurbishment to take place. It reopened at the beginning of 2014 and is nearly unrecognisable compared to its prior self. It now has a new shelving layout, computer space, teen area, junior room and a counter to greet customers, along with painted walls and carpeted floors.

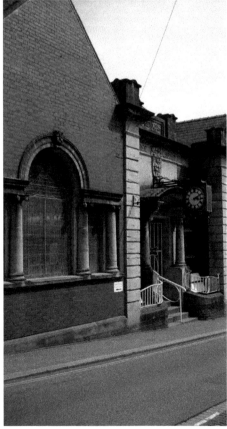

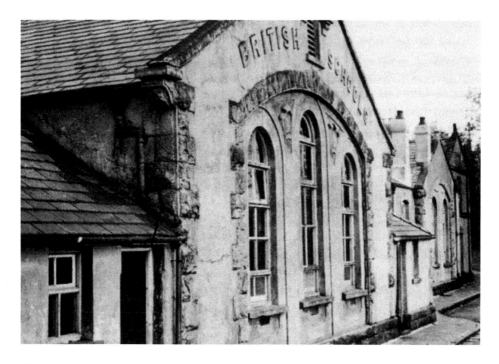

Abermorlais School

Built in 1868, Abermorlais Junior School was built to hold 1,000 children, but the most pupils at any one time were 600. The school was built by the British Schools Society on the British Tip, made up of industrial waste from the old Penydarren Ironworks. The school's name was chosen because the building stands on the banks of the River Morlais, which feeds the Taff. Among the school's most famous pupils were Lord Buckland, Lord Kemsley and Lord Camrose. Abermorlais School was one of the oldest schools in the borough, but during the 1950s there was talk of closing the premises. It was reported that, due to the school being built in the mid-nineteenth century, it was was no longer suitable for the education of the infants' section. It was also reported that the dining arrangements, lavatory and cloakroom accommodation were also unsatisfactory. The school stayed open until the 1970s, when it was finally closed. The children were moved to the new school in the grounds of Cyfarthfa Park, Cyfarthfa Primary, which is still open today.

Town Hall

Construction of Merthyr's town hall began in 1896 to designs of local architect E. A. Johnson of Johnson & Williams of Abergavenny. The building was completed two years later in 1898. The building was used for dual purposes: the front was used for council offices and the rear used for the county court, which included police cells (in the basement) and the council chamber doubled as a courtroom. The building was constructed using terracotta bricks and stained glass windows, and also had a clock tower. The town hall closed as the council offices in 1989. Up until then, the structure of the building remained unaltered, retaining its original fittings. The building was then bought and renovated into a nightclub called The Zone. The club was open until 2000 and then, when it closed, the building stayed vacant for several years, falling into disrepair as each year passed. In 2007, Merthyr Tydfil Housing Association Ltd acquired the building and, in 2011, funding for its restoration was granted by the Welsh Assembly Government (WAG) and Heritage Lottery Fund (HLF). Work began on the town hall and, on 1 March 2014, it was officially opened. Richard Harrington started the countdown and, as the doors opened, the old clock tower chimed for the first time in thirty years. Now part of Merthyr's Learning Quarter, the building has been rebranded as The Red House.

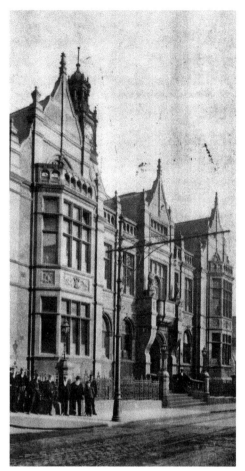

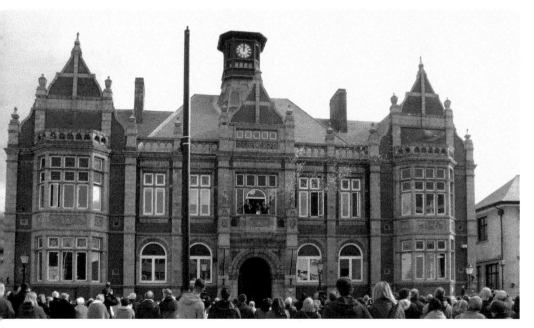

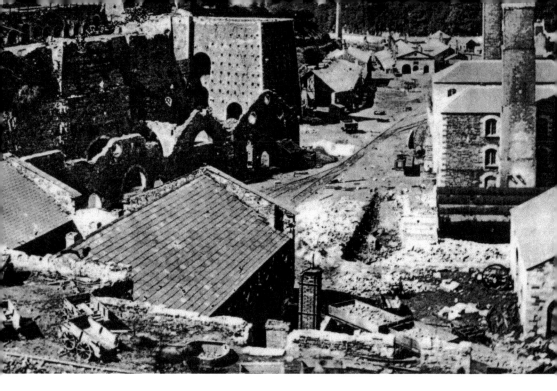

Merthyr Tramway and Trevithick Hall

By the beginning of the nineteenth century, Merthyr was developing from a rural community into the iron capital of the world. The Merthyr Tramway was built in 1802 and ran from Merthyr to Abercynnon. On 21 February 1804, the Penydarren locomotive, designed and built by Richard Trevithick for Samuel Homfrey of the Penydarren Ironworks, pulled a load of 10 tons and seventy men down the Taff Valley. The journey set off from the Penydarren Ironworks to the Navigation in Abercynnon, thus making it the first train. Over 100 years later, the Trevithick Trail was an initiative launched to celebrate the bicentenary of the first steam locomotive that changed the nineteenth-century world. The trail starts at the centre of Merthyr town and follows the Taff Vale. Along the route, markers point out historical significances in various locations, one of which is the Trevithick Tunnel. The tunnel was created for the locomotive and is arguably one of the oldest railway tunnels in the world for self-propelled steam engines. Part of the tunnel is still visible at Pentrebach.

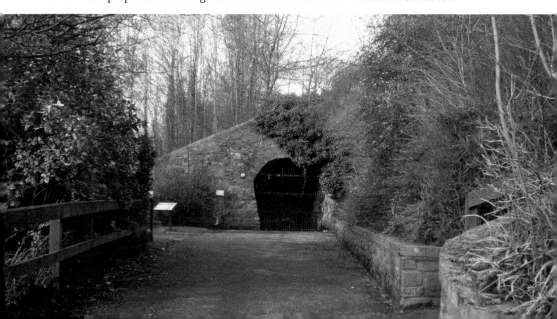

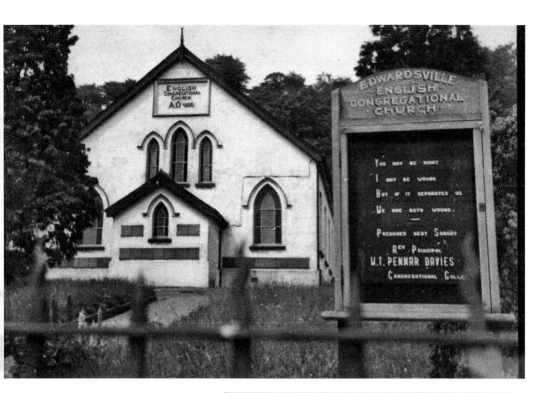

Edwardsville, Park Lane

At the beginning of the twentieth century, the only church group not to have an English chapel in Treharris were the Independents. Soon, members of Tabernacle chapel started meeting at the Quakers Yard School in Edwardsville. By 1906, land next to the school was acquired and a chapel was built. In October 1913, the chapel was badly damaged by the tornado that hit Edwardsville, but it was repaired with an added schoolroom in 1914. The chapel still stands and is in use as an active church. The site on which it stands is next to the school and near an area of prime development, where the Edwardsville baths used to stand. The site has matured and is one of the landmarks of Edwardsville.

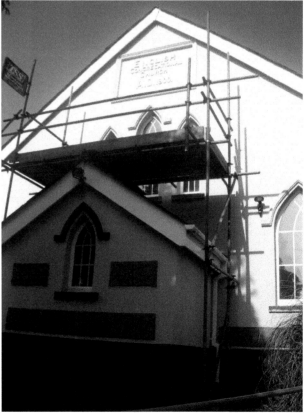

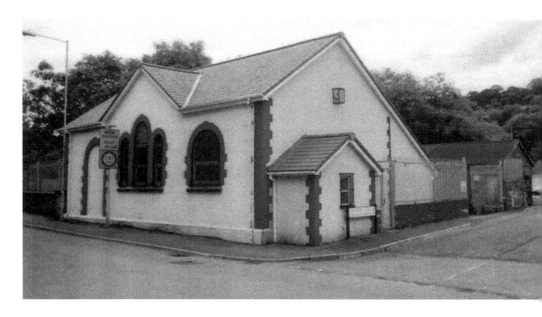

Aberfan Library

In 1901, there were many sites on offer to the Free Library Committee for a reading room in Aberfan. Eventually, the site offered by Griffiths & Thomas Solicitors was accepted. The library was opened by 1914, and in 1930 extra cleaners were needed to help the caretaker as the library was so busy. The building is in a very similar style to Troedyrhiw Library. It, too, was closed after efficiencies were made, and the building is now used as a meeting hall by various local groups. A new library has now opened in the Community Centre, bringing library services back to the village.

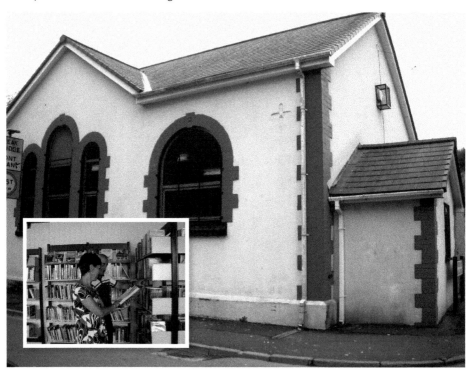

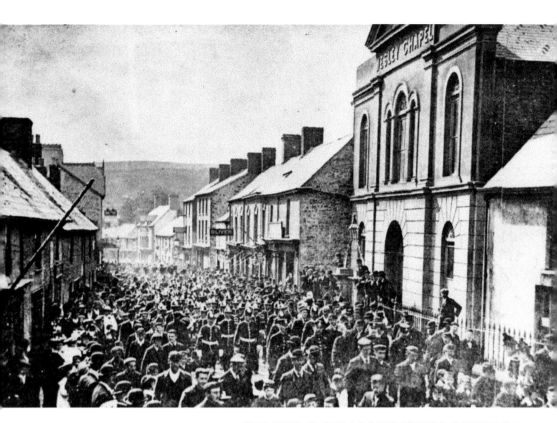

Wesley Chapel

The English Wesleyan cause started towards the end of the eighteenth century. Meetings were first held in the homes of the followers and then moved to the Long Room of the Star Inn. The original Wesley chapel was built beside the Morlais Brook in 1797, and was the first English chapel to be built in the area. By 1860, the construction of a new chapel by Messrs Morgan & Edwards of Aberdare had begun, and it was completed in 1863. After serving the community for many years, the chapel finally closed on the 30 December 1979 due to prohibitive costs for necessary repairs. The congregation then moved to Dowlais chapel. Later, the chapel was used as a furniture shop but then lay derelict for a number of years. Today, the chapel has had a new lease of life, with the refurbishment of the interior and exterior of the building. It is now used to hold local craft and antique markets.

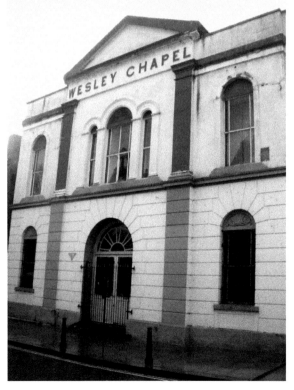

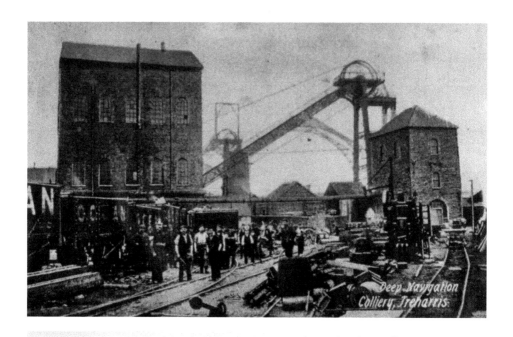

Harris Navigation Colliery and Parc Taff Bargoed

In the early 1800s, a mineral lease was granted on land owned by three local farms in Treharris. Led by Fredrick W. Harris, negotiations began for the rights to the lease. In 1872, Harris required the lease, and by October 1873 construction and sinking the pits began. Although 1 million tons of coal had been raised, the colliery found itself in debt. In 1893, David Davies took over ownership of the colliery and renamed it the Ocean Colliery. After nationalisation in 1947, the colliery was given its new name – Deep Navigation – by the National Coal Board (NCB). The NCB invested much in the colliery; however, by the 1990s, things were not looking good. After a geological report, it was announced that the colliery would be closing on Good Friday, 29 March 1991. The Deep Navigation colliery was located close to two other collieries in the area: the Taff Merthyr Colliery and the Trelewis Drift. When all three collieries were finally closed, work began on the combined site. Two new lakes were created, with parklands on either side. The new park opened in time to greet the new Millennium and was named Parc Taff Bargoed. The picture shows the coal seams worked at the Deep Navigation.

YMCA

The YMCA building in Pontmorlais was officially opened on 5 October 1911 by Mervyn Wingfield. It was based on the designs of two architects from Cardiff, Ivor Jones and Sir Percy Thomas. The purpose of the building was to provide a place for youths and men to congregate for amusement and recreation. The building had shops, a café, a lecture hall, a library, a gymnasium and numerous game rooms. In later years, the building was occupied by the Board of Trade and the Labour Exchange, and then eventually became the District Education Office. The building ceased to be used as the District Education Office in 1989. Throughout the 1990s, the building was derelict until it was purchased in 2001. The building's condition gradually worsened and, once again, it was sold in 2006 to property developers. To this day, the building still stands derelict and is in a terrible condition. At the beginning of 2014, it was reported that the building might be restored by the Carmarthenshire Building Preservation Trust and turned into an educational building once again.

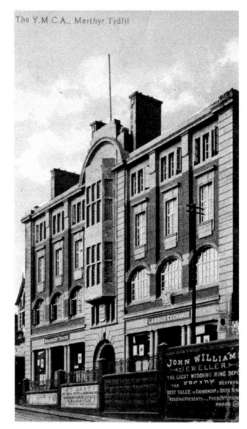

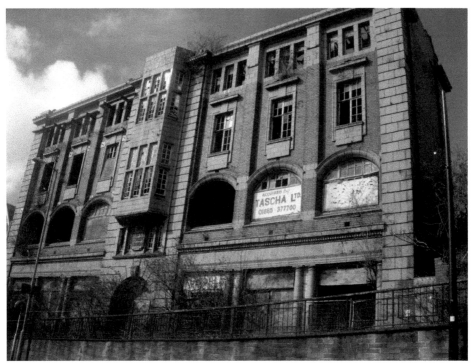

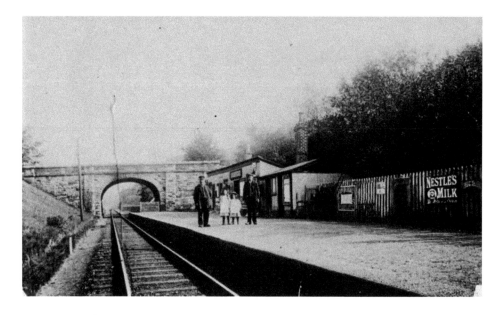

Pontsarn Station

Pontsarn station was built as part of the Brecon to Merthyr rail line, which had gained the unfortunate name of 'Murder Railway', owing to the amount of accidents on the line. Nevertheless, during the nineteenth century, thousands of people would still board the train during the summer months and head to Pontsarn for the day. The first through train came in August 1868 and, although it was only a small station, by 1873 there were twenty-one trains passing through per day. Eventually, the Brecon to Merthyr line was amalgamated with the GWR. The old Brecon to Merthyr system survived nationalisation into the British Railways. During the 1950s, Pontsarn station was renamed the Pontsarn Halt. Unfortunately, like many other stations, Pontsarn was closed during the 1960s. Today, although it is overgrown and the buildings have been dismantled, the old station platform is still recognisable.

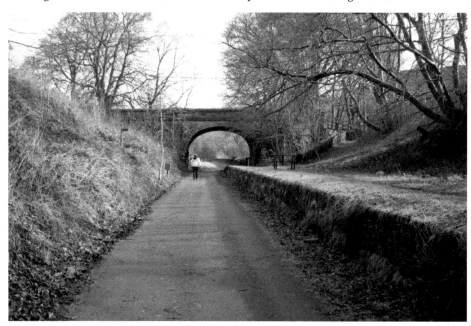

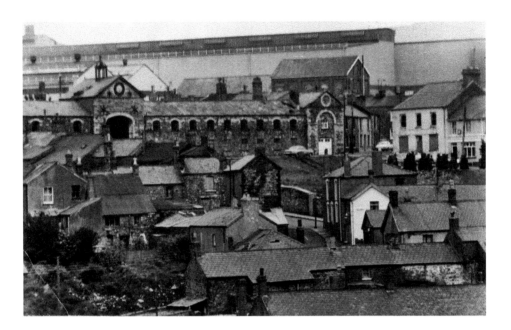

The Stables, Dowlais

Built on the instruction of Sir Josiah John Guest in 1820, the Dowlais Stables were designed to house the hundreds of horses used for haulage by the Dowlais Iron Company. Founded by Lady Charlotte Guest, the large first-floor rooms were used as classrooms for the children of the Iron Company's workforce until Dowlais Schools were built in 1854/55. After the Merthyr Riots of 1831, soldiers were stationed here permanently for several years. At the end of the nineteenth century, with the increase in rail travel, there was no need for the stables and the number of horses it could accommodate, and by 1930 the Dowlais Ironworks had closed. The stables were subdivided and in multiple ownership by the 1970s. Eventually, Merthyr Tydfil Heritage Trust took over the stables and began the work of stabilisation and consolidation. In the 1980s, Merthyr Tydfil Housing Association purchased the stables, restoring the façade, entrance block and flanking pavilions. The stables were then transformed into new flats for the elderly.

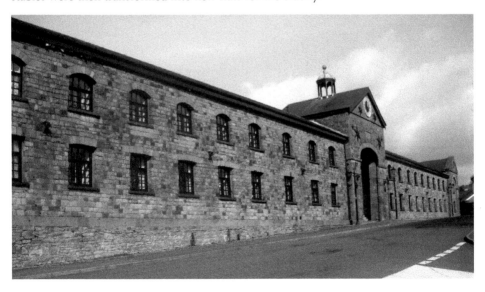

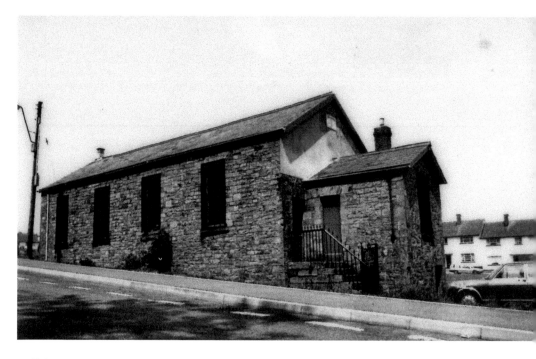

Gellideg

When members of Bethesda chapel began holding Sunday schools and prayer meetings in local houses, the cause at Gellideg began. In need of a more practical 'schoolroom', the members approached Robert T. Crawshay. He gave them land free of charge and also supplied materials for the building at a low cost. Construction of the new chapel began in 1860. The building was completed in 1861, and the trustees of Bethesda chapel took on the responsibility for the schoolroom. It catered for the religious education of the area and was also used for other religious activities and events. The chapel is still in use today by the local people.

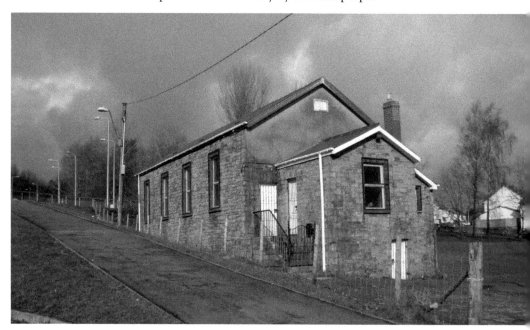

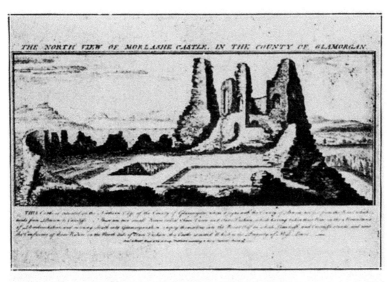

BUCK'S VIEW OF MORLAIS CASTLE, 1741.

Morlais Castle

Morlais Castle was built around 1270 on the site of a former Iron Age fort. It was built for the Earl of Gloucester and Lord of Glamorgan, Gilbert de Clare, at the farthest point of his land, with intentions of taking land from the Earl of Hereford and Lord of Brecknock, Humphrey de Bohun. Edward I wanted neither a significant castle in the area nor a conflict between the two lords, and so took the castle under his rule. It is thought that the castle was never fully finished. In 1833, the castle was excavated by Lady Charlotte Guest and amateur archaeologist G. T. Clarke. Over the hundreds of years since the castle was abandoned, the walls were gradually dismantled by locals, who used the stones for local buildings and farmers' walls. The only surviving feature of the castle today is a large crypt.

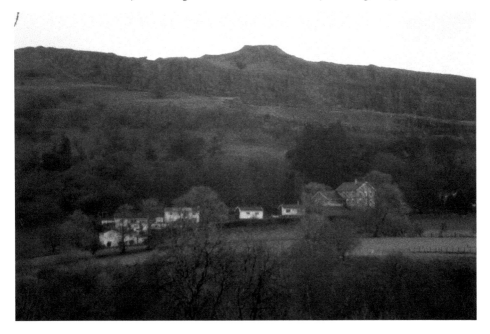

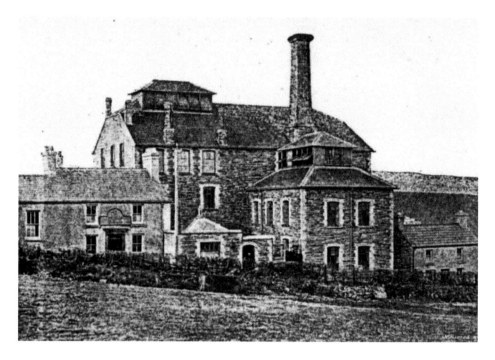

Heolgerrig Brewery

The Heolgerrig Brewery was originally built by Evan Evans in the 1840s. In a field opposite the brewery was the Six Bells Inn. After Evan Evans' death, his son, Christmas Evans, took over the business. A fire destroyed the original brewery in 1888, after which Christmas had new modern premises constructed. The Six Bells Inn, which once stood on the site of Heolgerrig Brewery, has now been converted to a family home. The rich tradition of brewing in Merthyr, which once boasted twelve brewers, now only boosts the Rhymney Brewery, Dowlais.

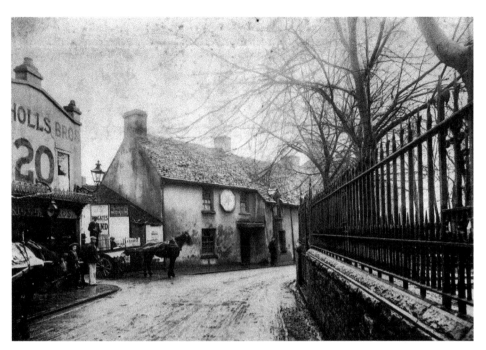

Star Inn and Lower End High Street
During the 1800s, Lord Nelson and Lady Hamilton made a surprise visit to Merthyr while on their Grand Tour of Wales. They visited the Cyfarthfa Ironworks, where Lord Nelson's cannon were cast. Pictured above is the lower end of Merthyr High Street; on the right is the cast-iron fence of St Tydfil's churchyard and opposite is the Star Inn. The public house was made famous when the lord and lady stayed the night. Where the Star Inn stood is the Lower High Street area, which now hosts a number of small shops, takeaways and barbers, as well as the Merthyr Tydfil Housing Association.

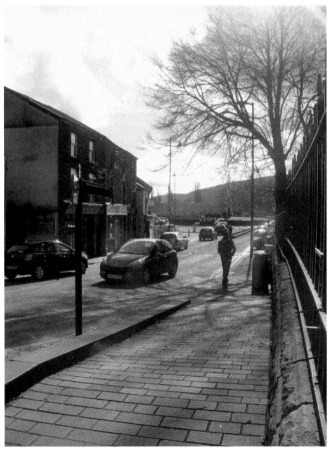

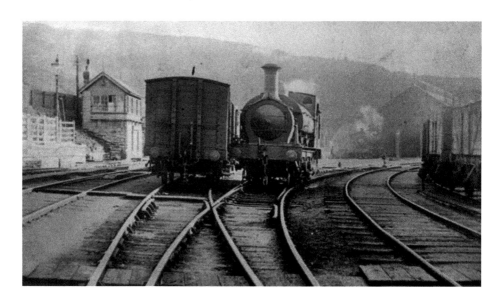

Caeharris Station, Dowlais

The Caeharris station was the terminus of the Rhymney Railway branch that went to Cwmbargoed, Bedlinog and Nelson. The original incorporation of the Rhymney Railway branch was in 1854, and railways were opened throughout the late 1800s. The station was situated behind the Antelope Hotel and, as well as public use, it was used heavily by the Dowlais Iron Company to bring in imported iron ore and send out finished goods. The station was used up until the 1960s, when the people of Dowlais could still catch the Caeharris train to Cardiff via Nelson, Ystrad Mynach and Caerphilly. Along with many other stations, Caeharris was closed in 1964. The area where the station once stood is now wasteland up to the new slip road, but the Antelope Hotel still stands in its original place.

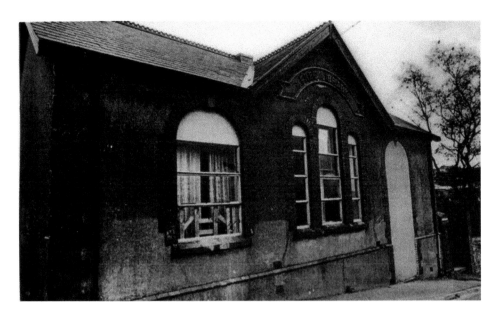

Penydarren Library

During the early twentieth century, the Free Libraries committee received a plan for the designs of a library to be built in Penydarren. The library was opened by 1902, and the committee gave instructions for certain magazines and newspapers to be supplied. The library proved to be quite popular with the locals and, by 1917, there was a demand for the library opening hours to change so that it was open more frequently for borrowers to issue books. Like many of the original libraries, Penydarren Library closed as the decline in industry saw people move out of the area. The site was sold and has now been redeveloped into private housing.

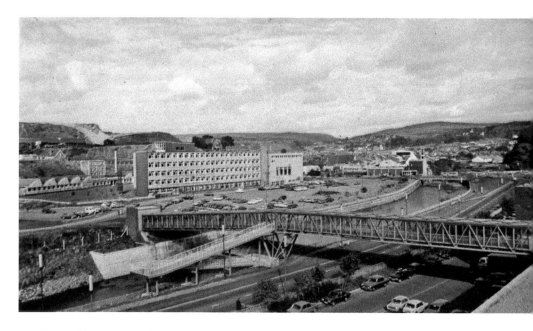

Merthyr College & Learning Quarter

Merthyr Tydfil College of Further Education was built on the site of the Ynysfach Ironworks. It was estimated that the whole project would cost over half a million pounds. Plans were submitted in 1950 and three years later work began on the construction. The college was built not only to provide technical and commercial training but also to be the centre of all cultural and recreational activities for the County Borough. The college was officially opened on 19 December 1955 by Mr S. O. Davies MP. Merthyr College served the students of Merthyr and its surrounding areas for the next fifty years. Before 2006, the college was an independent institution, but it became part of the University of Glamorgan Group in May of that year. In 2010, the Welsh Assembly Government reviewed the post-sixteen education system and it was decided to merge all sixth forms throughout the borough under one roof. In 2012, work began on the new college, which is situated just behind the old Merthyr College building. In September 2013, the new building was opened and now includes post-sixteen education up to higher education courses.

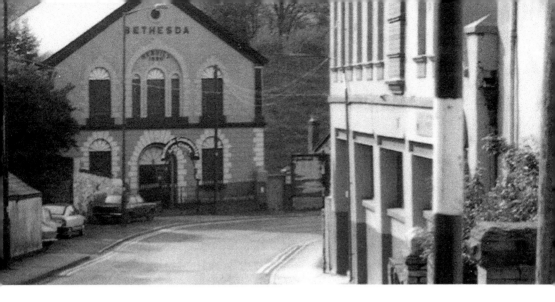

Bethesda Chapel

The congregation of Bethesda chapel first began meeting in the upstairs room of a blacksmith's. After two years, a larger premises was needed and so they moved to another blacksmith's forge. It was during this time that the congregation decided to build their own chapel, and they obtained a piece of land. The chapel was built at the start of 1811. The congregation grew and, in 1829, a new, larger chapel was built. During the 1850s, Dr Joseph Parry was a frequent member of the chapel, until he and his family moved to America. By the late 1870s, the congregation had grown, and by 1881 a newer, larger, more comfortable chapel was opened. The chapel served the community until its closure in 1976. The chapel was then converted and used as an arts centre until it was demolished in 1995.

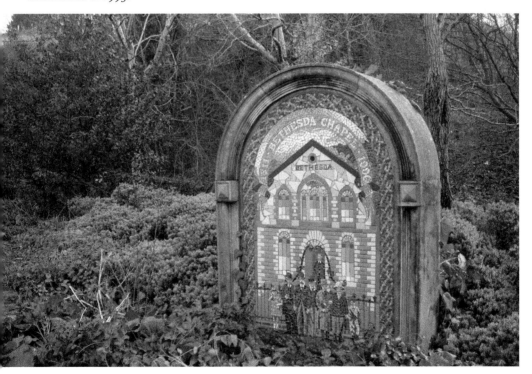

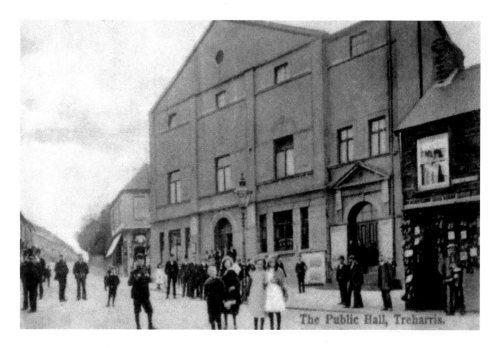

The Public Hall, Treharris.

Public Hall and the Square, Treharris

With the growing population in Treharris during the late 1800s, there was need for a public hall to be built. In order to raise the funds for the project, concerts were held and shares were sold. By 1893, the village public hall had been constructed on the Square and was ready to be opened. The hall consisted of a library, committee rooms and reading rooms. The hall was financially supported by contributions from local miners' wages. The Public Hall or Miner's Workmen's Hall served the Treharris community for the best part of 100 years. It was used for various community events and activities and eventually became a popular cinema known as The Place. Over the years, it was used as a bingo hall, a snooker club and even an indoor market, before it eventually fell into disrepair. During the 1990s, there were plans to save the building, but by 2000 the building was demolished. After years of being wasteland, funding was finally granted and, at the end of 2013, the newly rebuilt Square was officially opened as a car park and public space.

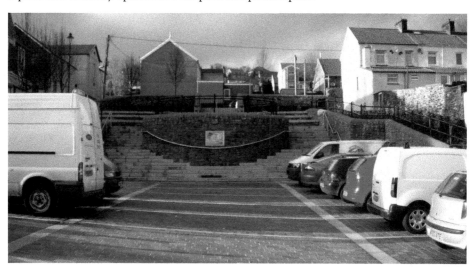

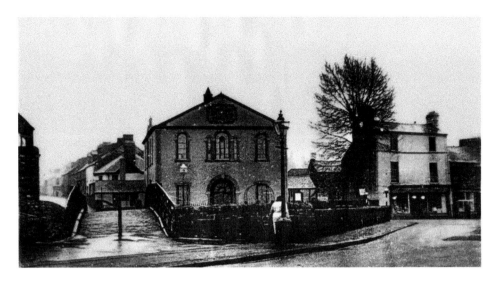

Ynysgau Chapel and the Civic Centre

In the early eighteenth century, Nonconformist worshippers were meeting in a small chapel in Cwmglo. The lease at Cwmglo expired in 1749 and, as the congregation was growing, it was decided to build a new chapel in the centre of Merthyr. Land was bought and the Ynysgau chapel was built. In 1811, the gallery collapsed due to overcrowding. By 1853, it was decided that a newer, larger chapel was needed. The new chapel was officially opened in 1854. The Ynysgau chapel was one of Merthyr's oldest and most important chapels. It served the town for over 100 years but, unfortunately, was demolished in 1967. In the surrounding area where the chapel once stood the Council Offices and Civic Centre now stand, built during the early 1990s.

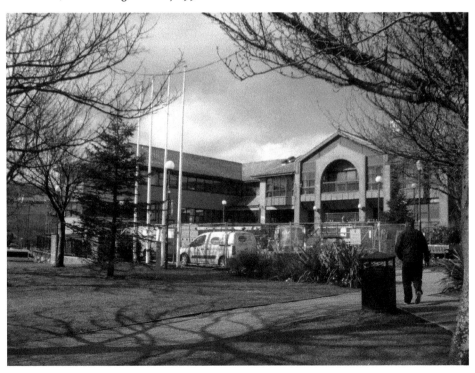

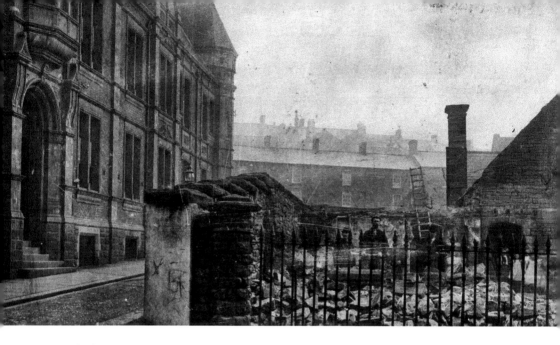

Central Library

In the early twentieth century, there were ambitions to build a Central Library in Merthyr Tydfil. It was decided to form a committee to secure a site for a new Free Library. In 1902, a letter was received from Andrew Carnegie, promising £6,000 for a library building and money towards two branch libraries for the district. Various sites were offered to the committee, and then, finally, in 1913, it was decided to acquire the site of the old St David's school. The building of the library started at the beginning of 1935 and was officially opened in November of that year. The Mayor Ald. Lewis Jones JP became the first book borrower from Merthyr's Central Library. Not much has changed at the Central Library save for rooms being changed for different uses. To this day, the exterior of the building looks exactly the same. In 2011, the Central Library was awarded a grant from CyMAL for the complete refurbishment of the interior. The building was closed to the public for a period of six months, the longest time closed since opening. The library was given a complete makeover, with a new layout and shelving, teen and junior spaces, reading rooms, computer rooms with new computers and new lighting, carpet and painted walls throughout. The library was officially reopened in 2012 by the mayor, Lisa Mytton, and Dowlais Male Voice Choir sang.

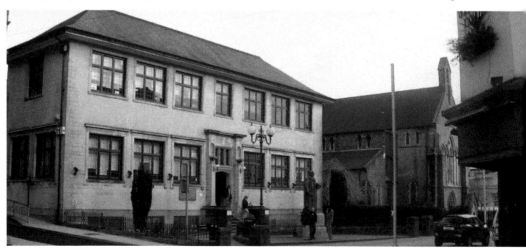

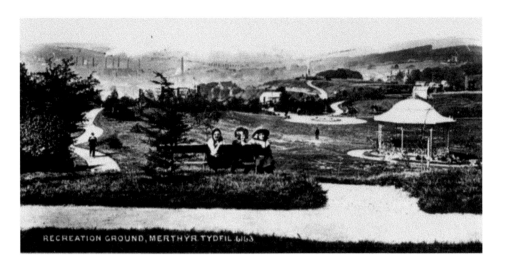

RECREATION GROUND, MERTHYR TYDFIL 6163

Thomastown Recreation Ground and Thomastown Park

Prior to the 1900s, the town's only parks were in private ownership and public access was restricted. With people living in overcrowded and unhealthy conditions, the town needed open spaces for exercise and fresh air. During the early twentieth century, land that was formerly Thomastown Tips and the Old Quarry was acquired to build a public park. It had extensive flowerbeds, borders, a playing pitch and a bandstand. Later, a bowling green and tennis courts were also added. Thomastown Park is home to approximately 17 acres of parkland. Locally, it is known as a 'beauty spot'. Today, the park still has many of its original features, including the bandstand, bowling green and tennis courts. Over the years, there have also been some additions, such as children's play facilities and a paddling pool, which is filled up with water in the summer months.

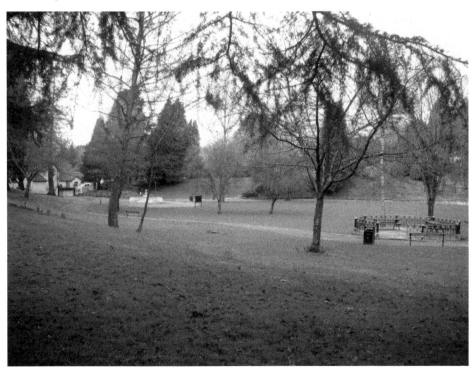

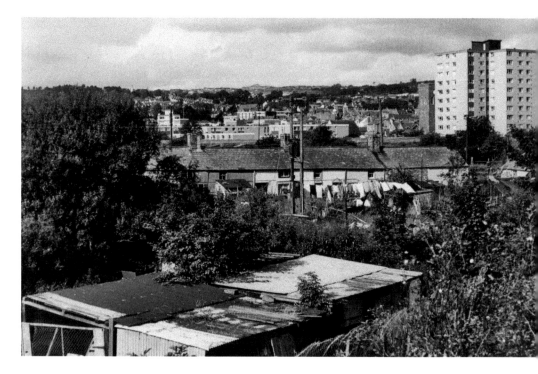

Rhydycar Cottages

The Rhydycar Cottages were built around 1795 by Richard Crawshay to provide housing for the workers in his iron ore mines. There were no basic facilities in the cottages, no piped water or toilet facilities. Each cottage had a living room with one bedroom above and, at the back of the house, a pantry and a second bedroom. After a devastating storm in 1979, a culvert above Rhydycar became blocked, sending water crashing down on the Rhydycar Cottages. As a result of the excessive damage, the cottages were demolished, but six were saved and rebuilt at St Fagan's National History Museum. The Rhydycar Leisure Park now occupies much of the land where the cottages once stood.

Saron

During the 1820s, a Sunday school was started in the area of Troedyrhiw by new residents Mr and Mrs Robert Davies. The Sunday school was a great success and so it was decided that a chapel should be built. In 1833, land was bought from Sir J. J. Guest, but it wasn't until 1835 that the chapel was opened. The congregation flourished, but soon the chapel became too small and a new one was built with enough land for a graveyard in 1852. Saron chapel served the village of Troedyrhiw for over 150 years. For a long period of time, it was one of the largest and most important buildings for the locals, and generations were christened, married and buried in its grounds. Sadly, the chapel was closed in 1983 and the building became derelict and the graveyard unattended. It was demolished in the 1990s. In 2009, a community group, Friends of Saron, was formed with the aim of rescuing the graveyard after thirty years of neglect. With help from various schemes and local groups, Saron graveyard is receiving much-needed attention.

SARON - THEN AND NOW

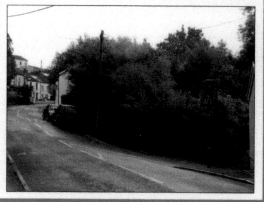

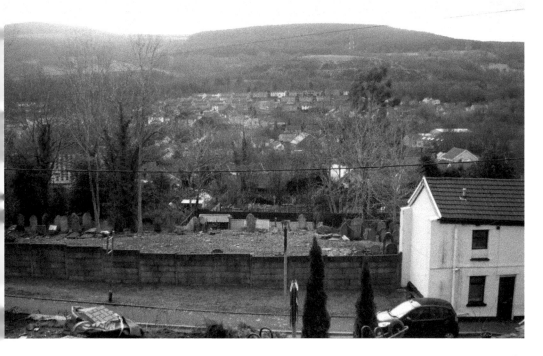

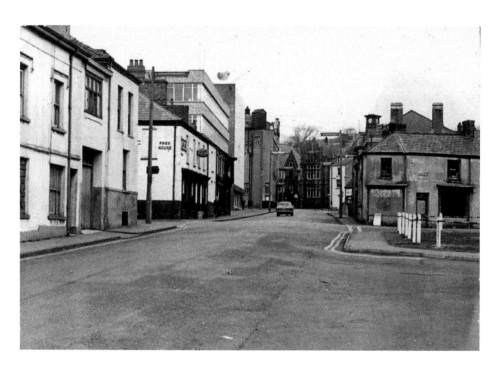

The Lamb Inn

The Lamb Inn public house was built during the 1850s and was the last link to Merthyr's 'China' area, notorious for its villains. It became one of the most popular public houses in Merthyr and was one of the first to have a Sunday rugby team. The Lamb was closed in 1985 due to the redevelopment of the area. On the final day of opening, the clientele held a 'funeral' for the much-loved public house. They carried a mock coffin from The Lamb to the Belle Vue public house on the High Street of Merthyr. The area where The Lamb once stood is now the road leading to Castle Car Park, and a war memorial now occupies the space.

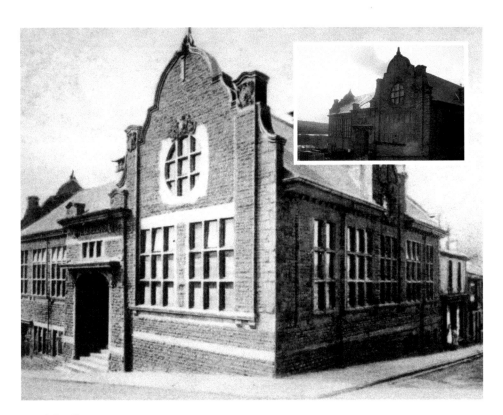

Dowlais Library

During the early twentieth century, Mr E. A. Johnson, architect of Abergavenny, was instructed to draw up plans for a new library at Dowlais. Plans were submitted in 1905 and two years later the library was opened. The library was officially opened on 10 January 1907 by Mr D. A. Thomas MP. A donation had been made by Mr Carnegie towards the funds of the building. For over 100 years, Dowlais Library has remained open to the public. The large basement of the library has been used for a variety of events and activities. In 2007, it celebrated its centenary with events and talks from former librarians, local historians, Lord Rowlands, Freeman of the Borough, and old films and slides were shown. In recent years, the John A. Owen suite has undergone refurbishment, and extensive work has occurred, clearing the huge backlog of book filing in the basement. The library now boasts the main non-fiction, Welsh and local history book collections for the borough.

CAPEL BETHEL LIVES ON

BY ELWYN BOWEN

Capel Bethel before it was submerged.

Pant-ar-daf, a popular spot for baptism in the days of Capel Bethel.

A view of the bridge during a dry spell.

WHEN Llwyn On reservoir was completed in 1926 the hamlet of Ynysfelin, many farms, the ruins of the Farmers Arms, the Red Lion Inn, the Pullinghill Capel Bethel, the Baptist Chapel disappeared under the waters for ever.

The cottages of Ynys-y-felin, the pulling mill, and Bethel Chapel stood on the side of the road which ran across the valley from the Farmers Arms to the Cwm Cadlan Road leading to Penderyn.

Approximately a hundred yards from the Cwm Cadlan sign post one can still see the mound of stones which was once the Baptist Chapel — Capel Bethel. The Chapel stood on the slope of the hill, on the left bank of the river Taf, overlooking the valley and in the Parish of Penderyn.

This was the oldest Nonconformist Chapel in the Parish of Penderyn. Founded in 1795 by five members of Seion Chapel, Merthyr, their first meetings were held in Pengoch Farm and later at a dwelling house at Ynysfelin.

SERVICE

Twelve members of Seion, inhabitants of Cwm-taf, left to join the gathering at Cwmtaf and in 1796 they decided to build a Chapel and Rev. D. O. Davies was ordained minister. The Chapel was built near the Pwll Coch Mill from which Ynys-y-felin gets its name.

In 1873 a number of members from the Cadlan Valley, Hepste and Pontören left and founded a branch of this Chapel in a dwelling house at Forshwen Penderyn.

Baptisms were often and they took place in the pool under Pont-ar-daf bridge. This bridge is often to be seen when the waters recede during dry spells. The membership in 1838 was 80.

In 1836 the Rev. D. O. Davies, who also farmed Ynystaf, resigned owing to ill-health and he was followed by his son the Rev. D. Davies. After labouring for over 40 years in the service of Bethel Chapel the Rev. D. O. Davies died in 1853 at the age of 88. His son the Rev. D. Davies died in 1869 at the age of 74.

The Rev. J. Hughes became minister for a short time and was followed by the Rev. J. Salathiel of Cefn Coed who was minister for 20 years. When he died in 1901 he was followed by the Rev. David Jones of Merthyr. During his ministry the members were informed by the Cardiff Corporation of their intention to construct the Llwyn Onn Reservoir.

A new chapel was built across the river on land adjacent to the Hendre on the Parish of Vaynor. The mortal remains of the faithful; the Rev. D. Davies and his son Septimus Jenkins the conductor, Herbert Davies Hendre, Daniel Morgan Pentheol, David Lewis Gelli, Corporal Major Jenkins and many others lie in the new Bethel.

Bethel Chapel, Cwmtaff and Pontsticill Reservoir

During the late eighteenth century, members of the Zion chapel in Twynyrodyn began meeting at a farm in Cwmtaff, and then moved to a house at Ynysfelin. When the numbers increased, the house was ordained to hold religious meetings. By 1799, the congregation decided to build their own chapel. The chapel continued to grow and a new one was built in 1866. Where a small village community once stood, Pontsticill Reservoir now occupies the land. It was decided in the early twentieth century to merge the reservoirs, which meant flooding the land. By 1927, the reservoir had been constructed. Lying under the water is all that remains of the small village. The graveyard of Capel Bethlehem was moved and its memorials recorded. When the water levels are low, you can sometimes see the top of the chapel's entrance.

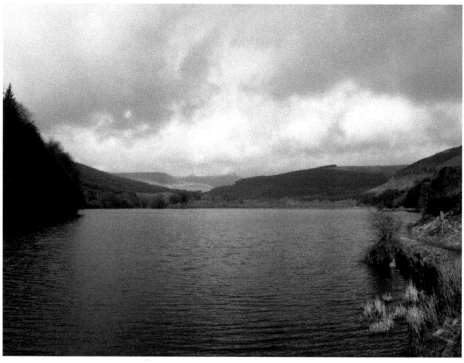

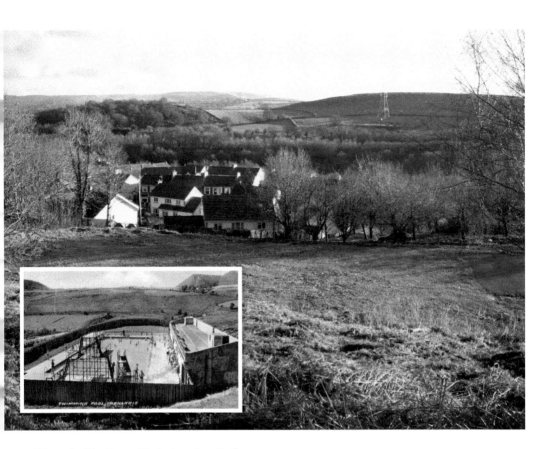

Edwardsville Open-Air Swimming Baths

Edwardsville Open-Air Swimming Baths were originally opened in the late 1920s or early 1930s, as a recreational area for the people of Edwardsville and the surrounding area. The outdoor baths stayed open for the next fifty years or so. The baths were so popular that, at peak times, people had to take it in turns to use the pool. After nearly fifty years, the open-air swimming baths were converted into a modern 'covered' swimming pool in 1986. The baths served the area for the next twenty years, but by 2008 plans for the closure of the baths were put in place. The council argued that the baths were too costly to keep open and that a new leisure complex at Rhydycar, with state-of-the-art facilities, would be available for everyone. After numerous petitions and the failure of the pool to sell at auction, the destruction of the once much-loved baths began in September 2010.

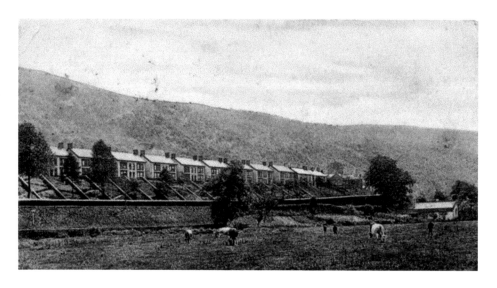

Troedyrhiw Farm and Afon Taf High School

Although Troedyrhiw developed as a coal-mining community, it has preindustrial roots, with farms and a corn mill in the village. The farm, known as Troedyrhiw Farm, dates back to the early 1100s, when the farm was part of Ifor ap Meurig – Ifor Bach's estate. The ancient name for the farm was Tir Rheol Gymrwg. Around 1789, the property was sold to the Dowlais Iron Company. The final owner of the farm was Mr William N. Jones. The farm remained in evidence until the late 1960s. During the early 1960s, the Ministry of Education called for a reorganisation of secondary education. The grounds of the ancient farmhouse were the perfect place for such a new school. Afon Taf High School was officially opened by the Minister on 8 July 1968.

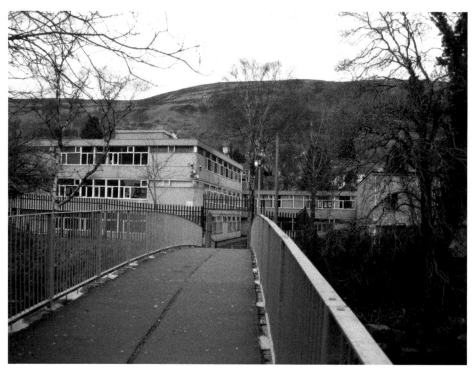

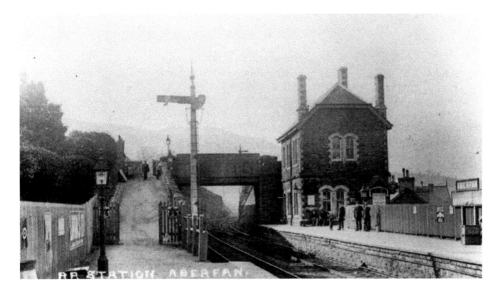

Rhymney Rail Station Aberfan

Rhymney Rail (RR) opened many lines throughout the north of the valleys, its main aim being to reach the ironworks and collieries. Aberfan station was opened in 1886 by a joint operation between the GWR and RR, the Quakers Yard and Merthyr Railway. In 1902, the station was renamed as Aberfan for Merthyr Vale station. During the grouping of 1923, the rail line became part of the GWR. The 1930s saw the station revert back to its earlier name of Aberfan station. The nationalisation in 1948 saw the ownership of the Aberfan station passed on to the Western Region of British Railways. The station was closed by the British Railways during 1951. The station and platform have now been demolished and very little evidence remains that the railroad once made its way through the area.

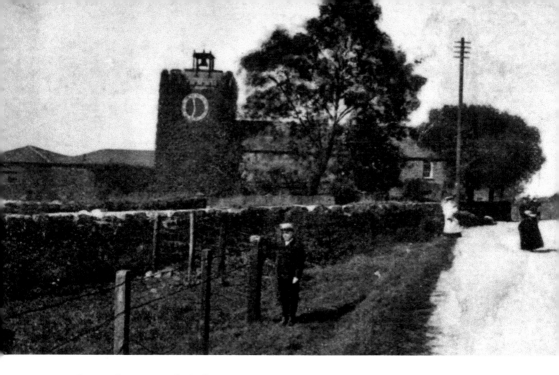

The Pandy Farm and Clock Tower

The Pandy Farm is thought to have been built during the fourteenth century and owned by the Earl of Plymouth. The original clock tower was built in 1816 by a Bristol firm on the instruction of William Crawshay. The clock has three faces angled towards the Cyfarthfa Ironworks. It was replaced in 1856 by a mechanism made on the Cyfarthfa Ironworks under the direction of George Cope-Pearce, the chief engineer. After years of bad weather and neglect, the Pandy Clock Tower was in a dire state. During the 1960s, the tower received a much-needed rebuild of its roof, along with renovation of flooring, stairs and windows. The old weight system that operated the clock was also replaced with an electric mechanism. The refurbishment took six months and cost £2,500, some of which was granted through funding.

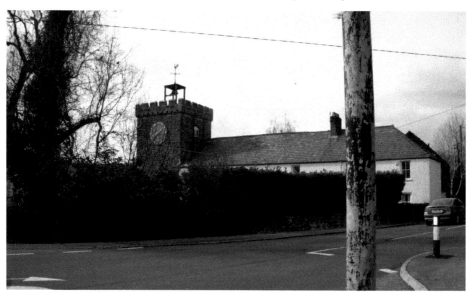

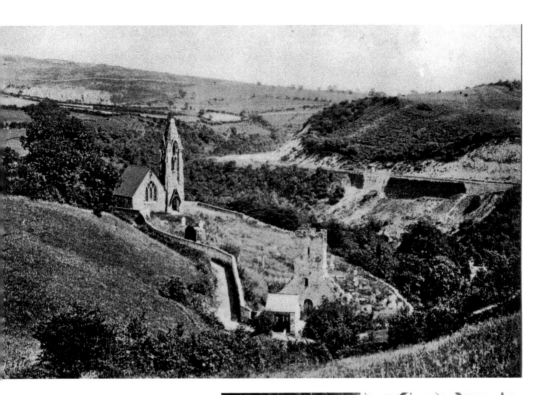

Vaynor Church

The original Vaynor church was built sometime during the eighth or ninth century. This church survived until the thirteenth century, when it was destroyed by a fire during the Battle of Maesvaynor in 1291. A new church was built to replace the original, but by 1867 it had become derelict, and once again a new church was built. In the picture above, you can see the remains of the old church and the one built to replace it. The Crawshays had another new church built, which was completed in 1870. One of the most remarkable memorials in the churchyard is the grave of Robert Thompson Crawshay, which is surrounded by iron bars. A huge slab of stone sits atop the grave with the inscription 'God forgive me'. In the picture above, we can see the Vaynor church that was built to replace the original and the church the Crawshays had built.

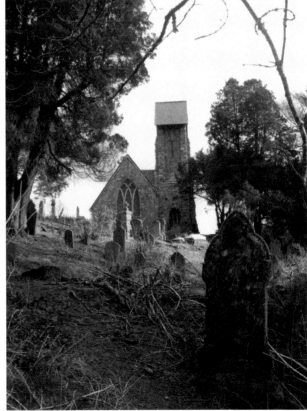

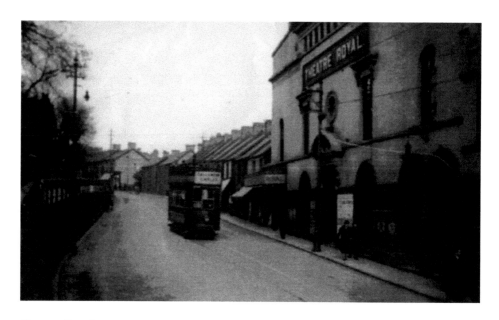

Theatre Royal

From early in the 1850s, Merthyr had a history of travelling theatre companies visiting the town. As there were no theatre buildings in the area, they would perform in the market square. Finally, in 1891, the Theatre Royal was opened, designed by Merthyr architect T. C. Wakeling. During the 1920s, the theatre was refurbished, with the auditorium being upgraded with Art Deco paintings and borders. By the 1930s, the theatre also housed a cinema. The theatre finally showed its final film in 1966, and closed its doors as a theatre in the late twentieth century. As the demand for bingo halls grew, the Theatre Royal was transformed into a bingo hall. The building stayed in use for many years, but eventually closed during the 1990s. Since its closure, the building has fallen into a terrible state of repair, and there have been talks of converting it into new homes, but to date it still stands derelict.

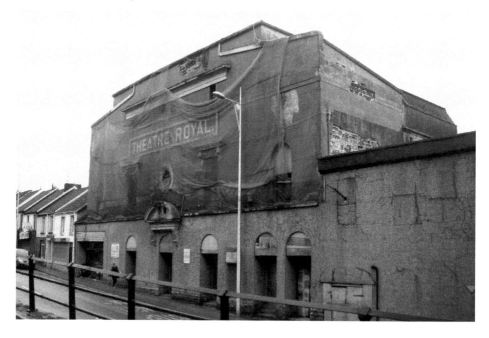

Dowlais Engine House

The Dowlais Engine House was originally built in 1905, as part of the Dowlais Ironworks. However, as the industry changed, the Engine House was used for many different purposes, from second-hand car sales business to a toy wholesaler, and then finally as a storage facility for the chocolate factory across the road. OP Chocolate was founded originally in 1938 in Treforst but it made its way to Dowlais in 1963. Today, the Engine House is used as the home for the Pant & Dowlais Boys & Girls Club, and the aim of the charity is to develop and educate the young people of Merthyr. The Engine House is used for a variety of activities, from training sessions to conferences. There is a room for hire and it offers a myriad of activities for children of all ages.

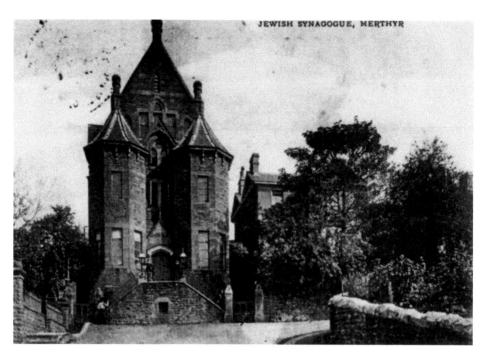

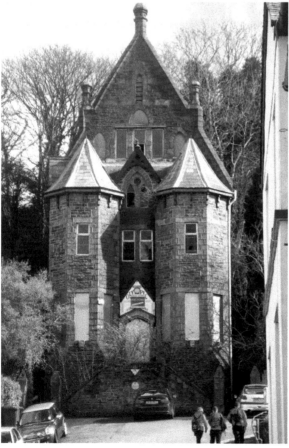

The Synagogue

During the nineteenth century, there was a vast increase in the amount of people who moved to the valleys to work for the coal and iron industries. The Jews were one group of people who made the move. The Jewish congregation of Merthyr was established in 1848, and the first synagogue was erected in the early 1850s in John Street. This was replaced by the prosperous congregation with the synagogue in 1872–75. At its height, the Jewish population of Merthyr rose to 400. By the end of the twentieth century, the Jewish community in Merthyr had almost vanished. Due to a lack of numbers for the congregation, the synagogue ceased holding regular services in the 1980s. Later, the building was sold and became a Christian Centre and gym. The synagogue is now a derelict building.

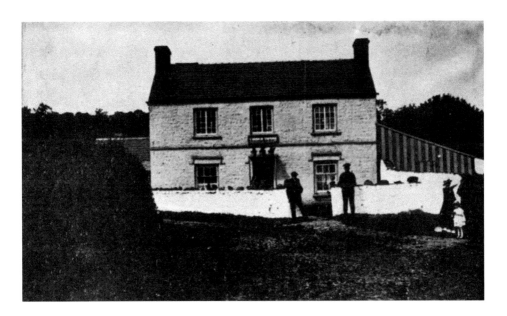

Church Tavern, Pontsarn

The foundations of the building are believed to date back to as early as the thirteenth century, when a tithe barn stood on the land. This building, however, is a seventeenth-century construction. During the eighteenth century, the first floor of the building was used for the local circuit court. While the court was in session, the room could be divided by three moveable oak panels. The Church Tavern has been closed for many years and has been converted into a private home. The area and house have not changed much over the years. The house itself is still recognisable but has been modernised and had an extension built. It is situated in an area of natural beauty and is frequently passed by walkers and cyclists.

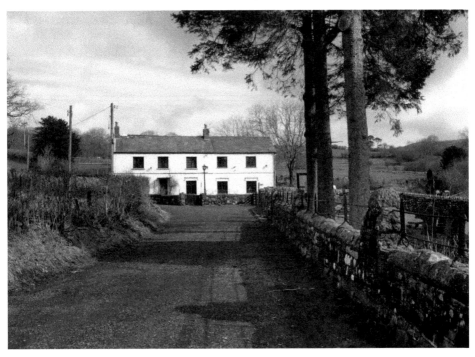

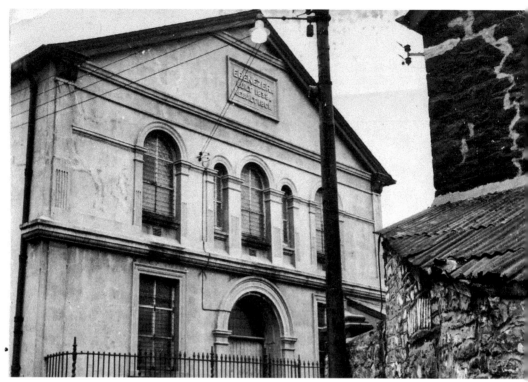

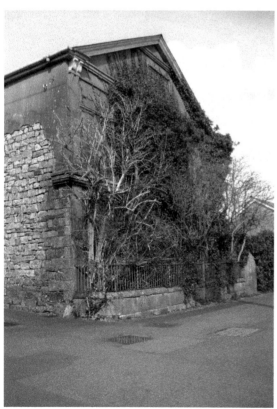

Ebenezer, Pontycapel Road

The cause began in 1836 when members of the Bethesda chapel began meeting in Cefn Isaf. As their congregation grew, it was decided a year later to build their own church. When the Chartist Rising began in 1838, many of the churchgoers supported their cause. Over the years, this caused many difficulties, such as problems with ministers and within the congregation. Eventually, Ebenezer was excluded from the Independent Union and other Independent chapels. By 1859, the chapel reconciled and joined with the Independent Union once again. This saw the chapel's congregation grow once more.

The chapel was in use for the next 100 years, but the 1960s saw the congregation decline. Unable to fund the building, it closed during the 1970s. Today, the chapel still stands in its original location, but has been derelict for many years, as can be seen by the greenery growing out of the building and state of its external walls.

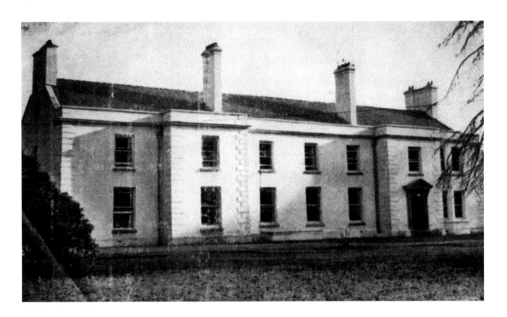

Pentrebach House

Pentrebach House was built for the ironmaster Anthony Hill in 1850, and is situated right up against the boundary of the industrial area. By 1861, he was living in the house with his widowed sister and was employing ten servants. After Anthony Hill's death, the house was owned by N. F. Hankey, the owner of the Plymouth Collieries. By 1871, the last of the Hills, Plymouth, had died and the house was split into two separate houses. During the 1950s and 1960s, the house was converted into homes for the elderly. The home closed in 1989. The house was deteriorating and there were unpopular discussions about plans to demolish the house. However, after many proposals, the house was bought by Whitbread PLC, who converted the house into a Brewer's Fayre public house. Today, the house still runs as a pub, operated by Table Table.

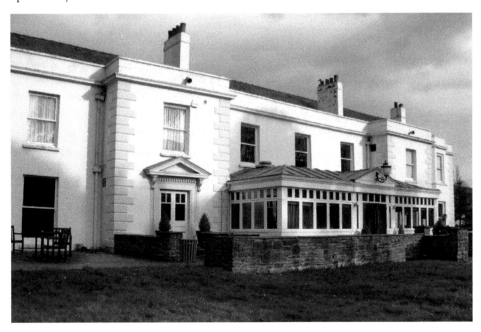

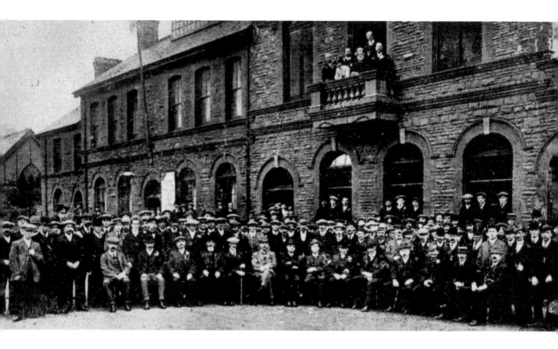

Gordon Lennox Club, Nixonville

The Gordon Lennox Club was built around 1901. It is associated with Gordon Lennox, the proprietor of the engineering company Brown-Lennox in Pontypridd, and he was also the president of the East Glamorgan Conservative Association. On the walls of the club there was once a pair of skis on display rumoured to belong to an Irish Arctic explorer. The above picture shows the opening of the club. The Gordon Lennox Club is still in operation and is an important landmark in Merthyr Vale. The Nixonville community grew up around the Taff Colliery, which was developed by John Nixon in 1869. The building of churches, clubs and other community infrastructure was down to the insistence that such facilities be provided by Merthyr Tydfil Council.

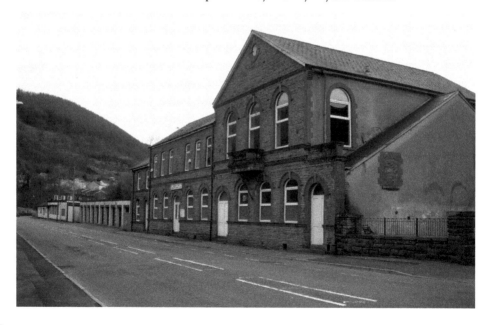